W9-CAN-241

THE BEST CAMERA

IS THE ONE THAT'S WITH YOU

iPHONE PHOTOGRAPHY BY CHASE JARVIS

The Best Camera Is The One That's With You™
Chase Jarvis

New Riders
1249 Eighth Street
Berkeley, CA 94710
510/524-2178
510/524-2221 (fax)
Find us on the Web at www.newriders.com
Find Chase on the Web at www.chasejarvis.com
To report errors, please send a note to errata@peachpit.com
New Riders is an imprint of Peachpit, a division of Pearson Education

Editor: Ted Waitt
Production Editor: Lisa Brazieal
Interior Design: Chase Jarvis Inc.
Indexer: Chase Jarvis Inc.
Cover Design: Chase Jarvis Inc.
Cover Image: Chase Jarvis

ISBN-13 978-0-321-68478-3
ISBN-10 0-321-68478-8

9 8 7 6 5 4 3 2
Printed and bound in the United States of America

FOR KATE

ACKNOWLEDGEMENTS

A whole bunch of work went into making this little book and I owe many thanks to many people.The crew: Kate, Scott, Dartanyon, Mikal. Alex, you're in there too. The page gracers: Mario, Scott, Kevin, Bob, Garnet, Snow, Cody, Vivian, Abbie, Andew, Will, Saba, Bill. New Riders: Ted, Nancy, Scott, Sara Jane, Lisa, Charlene. New agent: Nancy Stauffer. New friends: Kirk, Martin, Joe, Ubermind, Gary, Marita. To the makers of all the iPhone photo apps out there, especially the ones I played with the most: Photogene, CameraBag, TiltShift. To all of you who—through your pictures, blog posts, comments, tweets, Facebook messages, and emails—have contributed to this community. And finally, to my family and my friends: thanks for putting up with me.

FOLLOW CHASE JARVIS ONLINE

www.chasejarvis.com/blog
www.twitter.com/chasejarvis
www.facebook.com/chasejarvis

ABOUT THESE IMAGES & MY NEW iPHONE APP

 None of these images have been retouched or altered in Photoshop—or any other piece of software outside of the iPhone. They've all been edited exclusively with native iPhone applications.

While there are a number of good iPhone applications that perform certain tasks quite well, in my experience none of them—individually or together—have met my need to create these images and share them easily.

Until now.

Introducing my own iPhone application called—appropriately enough—**Best Camera**. It has been in development throughout the course of creating this book.

With this single application, you can creatively edit and share your iPhone images more simply than ever before. There's a unique set of filters and effects that can be applied at the touch of a button. Stack them. Mix them. Remix them. Virtually infinite creative possibility with your photos.

And what good is taking a picture if it's not easily shared? **Best Camera** allows you to share directly via Twitter, Facebook, a host of other sites, and **www.thebestcamera. com**, a new online community that allows you to contribute to a living, breathing gallery of the best iPhone photography from around the globe.

I am proud of the ecosystem we've created: this book, this app, and this community. Join us. I look forward to seeing your pictures.

You can buy **Best Camera** ($2.99) in the iTunes App Store or by visiting **www.chasejarvis.com/bestcamera**.

CONTENTS

INTRODUCTION

What you're holding in your hands is a chunk of me. My guts. My process. My study. It's a look into the production of my ideas. These pictures, all taken with my iPhone, make up my visual notebook—a photographic journal—from the past year of my life. Though *The Best Camera* closes the door on this period, this ongoing study continues to fuel my curiosity and provide boundless inspiration. It is an invaluable reference and will continue to inform my future bodies of work.

It is said that Rodin molded hundreds of hands in preparation for creating the hand of *The Thinker*, as he explored musculature, the folding of fingers, and on and on. Undoubtedly, each of those hands merits the label "art" in its own right. It's in this same vein that I consider the images in this book. While each iPhone picture certainly contributes a thread to the overall fabric of my creativity, it's of a deeper—or, perhaps paradoxically, simpler—interest to me that each iPhone image ultimately stands on its own. Two megapixels at a time, each photograph reveals how I process the visual information around me, how I see the world.

These images remain a visual journal, but gathered and bound together this book becomes a stake in the ground. With it, I hope to underscore—perhaps help legitimize—the idea that an image can come from any camera, even a mobile phone. Inherently, we all know that an image isn't measured by its resolution, dynamic range, or anything technical. It's measured by the simple—sometimes profound, other times absurd or humorous or whimsical—effect that it can have upon us. If you can see it, it can move you.

For me, the iPhone has been a dream come true. One button. Always with me. Incredibly accessible. There's no losing sight of the work at hand by way of more complicated gear. Writers have notepads, painters have sketchbooks, and I have a camera that's always with me. Chances are, you do, too.

If we allow it, photography can escape the technical trappings of so many other artistic endeavors. It's accessible, nearly ubiquitous today. And it's given us an opportunity—more than ever before in history—to capture moments and share them with our friends, families, loved ones, or the world at the press of a button. It's the moment. The little snippet of life unfolding in front of your lens—whether that be glass, plastic, or a pinhole in a cardboard box.

As an artist, I feel more free with the little camera built into my iPhone than I ever have with any other camera. I somehow recovered an innocence I'd lost, and I was able to see the world again for what it is: a beautiful, funny, sad, honest, simple, bizarre, and wonderful place. If taking pictures helps you see this, then keep shooting. The best camera is the one that's with you.

Chase Jarvis
July 2009
37,000 feet, somewhere over Colorado

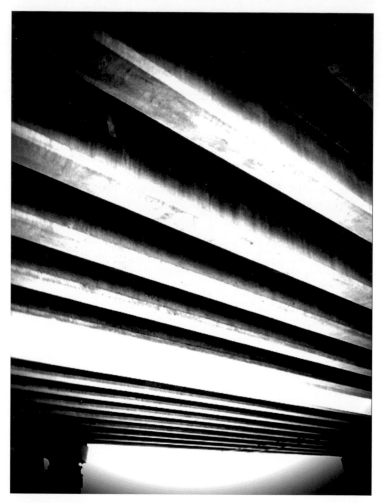

2 under the freeway, seattle

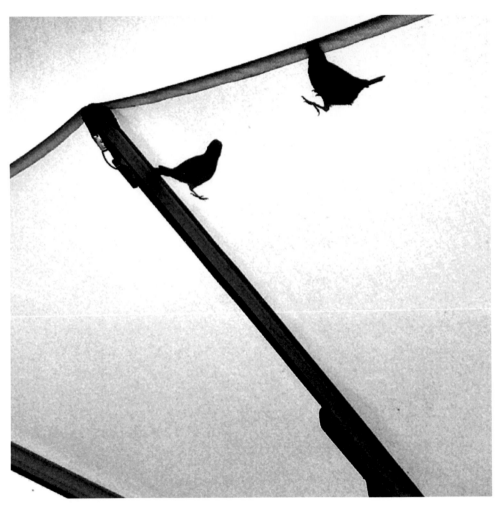

birds that ate my breakfast, kona 3

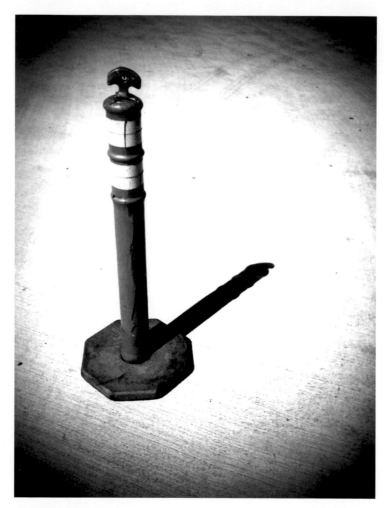

4 this is called a delineator post

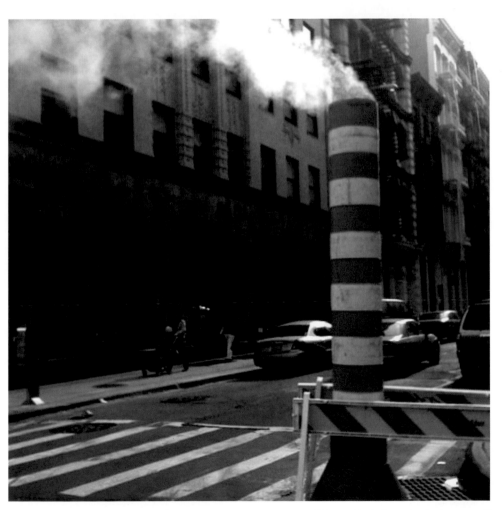

a different kind of smokestack, nyc 5

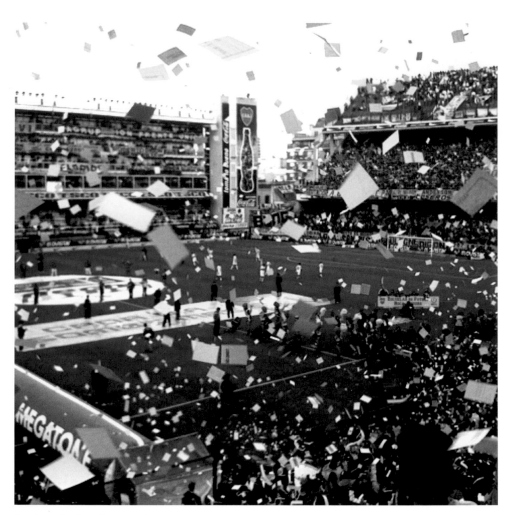

6 boca juniors, buenos aires

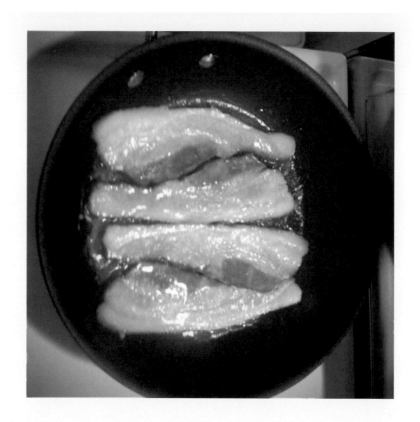

8 bacon tastes good

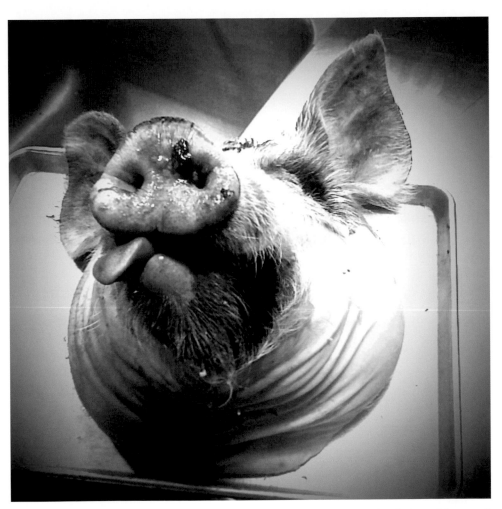

I began shooting iPhone photos as a means to both escape and yet stay connected to my craft. It was an exercise to hone my ability to better see

my world.

view from my hammock, seattle 11

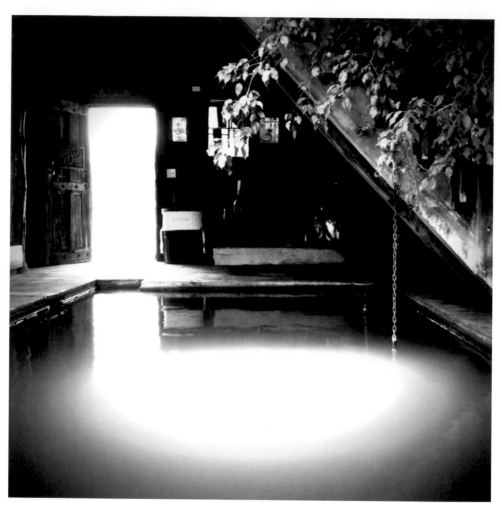

12 dunton hot springs, telluride

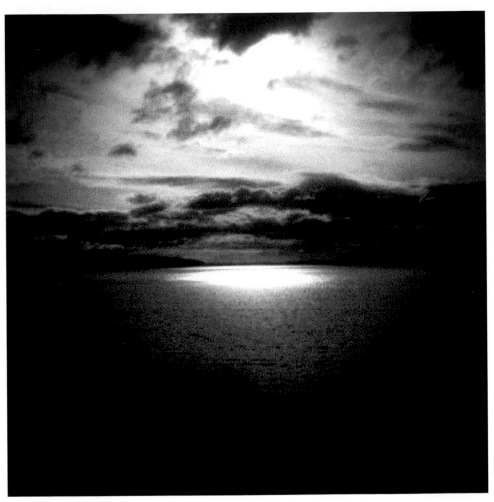

14 skylight reflecting on an amber pool

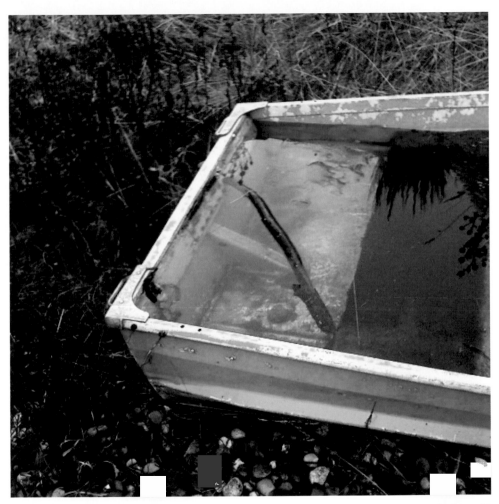

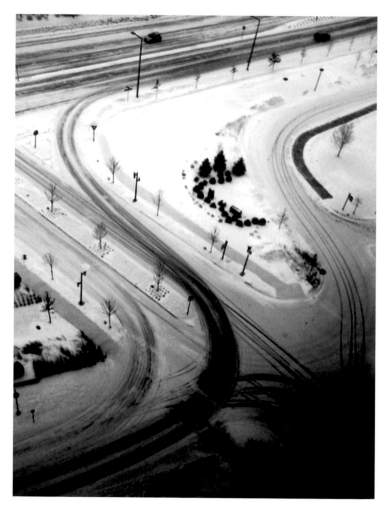

16 snowy roads, minneapolis

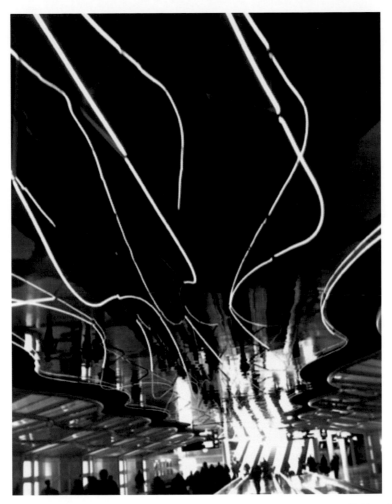

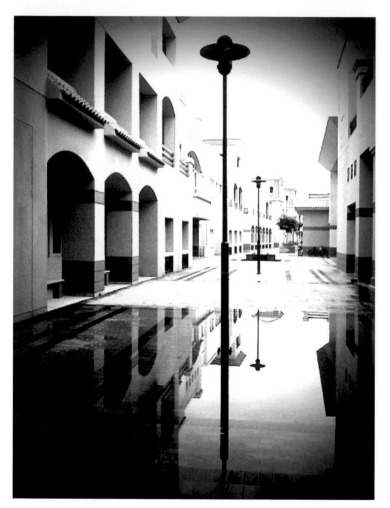

18 after the rainstorm, dubai

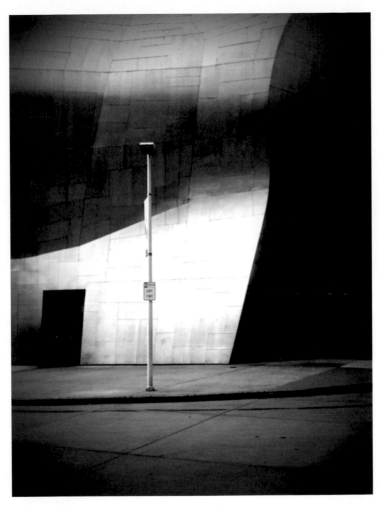

bent metal and a lamppost 19

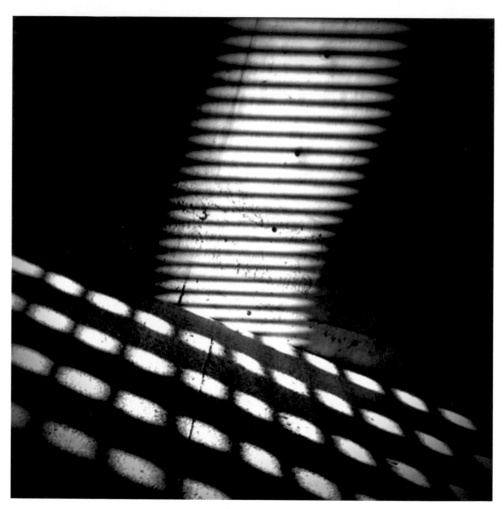

20 garage door shadows

I don't want more settings or buttons. I want less.
Less is the new black.

22 mostly snowy bench

24 institutional apartments, denver

26 april showers bring, seattle

It's not always about creating pictures. It can be about **finding ones that already exist.**

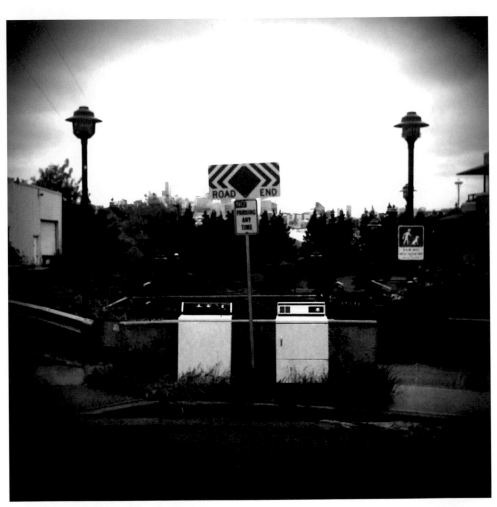

30 chain on brick

cat tail on zebrawood 31

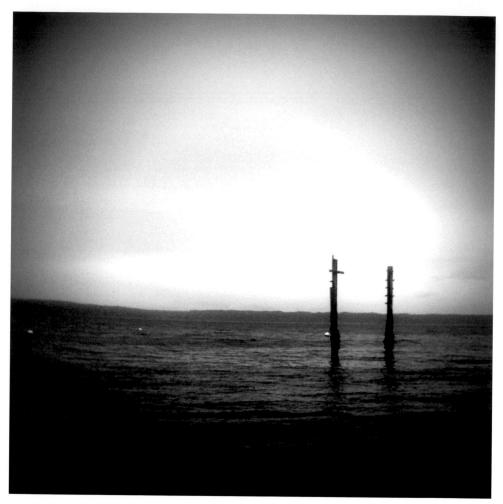

32 goalposts, camano island

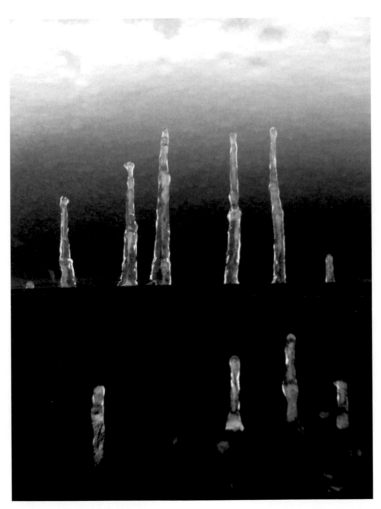

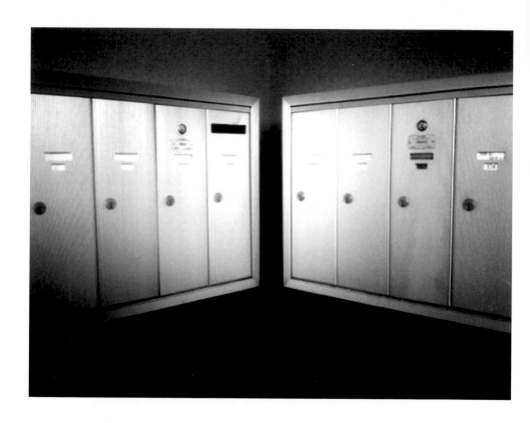

34 mailbox perspective

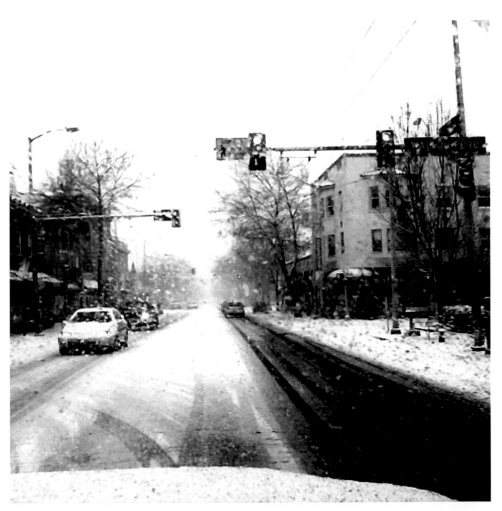

Kitsch makes for some of our culture's
most interesting subjects.

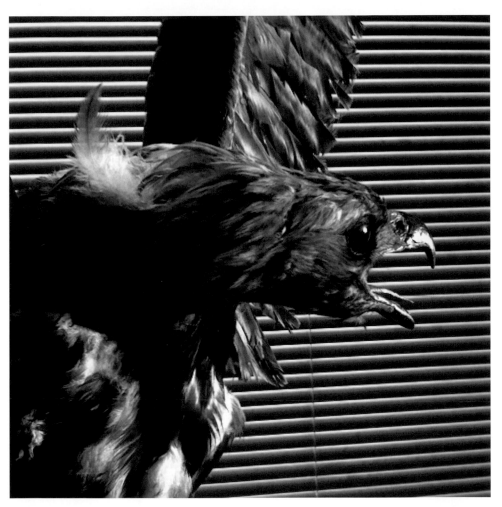

taxidermy eagle with venetian blinds 37

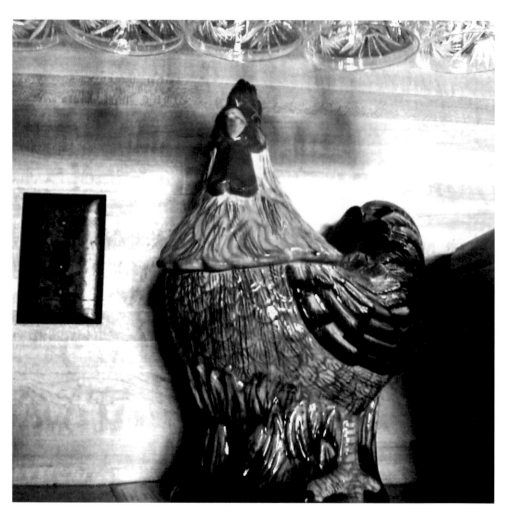

38 cockie jar, salt lake city

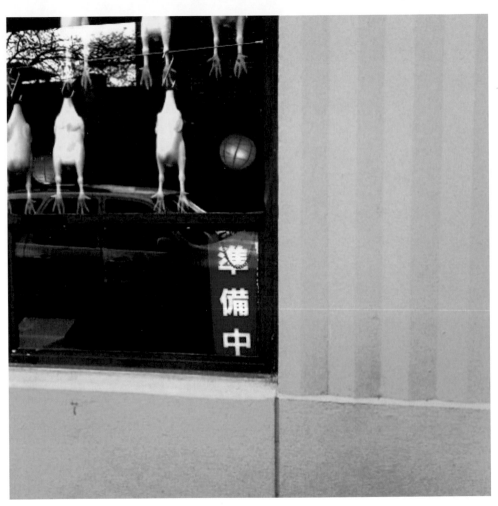

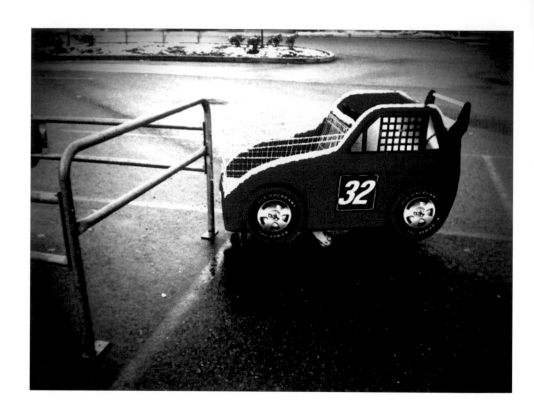

pimp my shopping cart

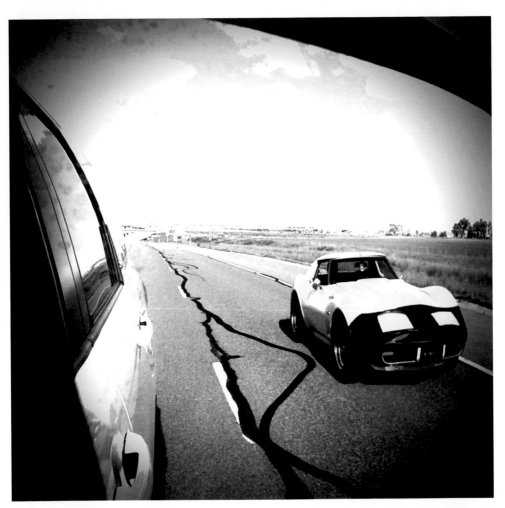

classic vette, boulder 41

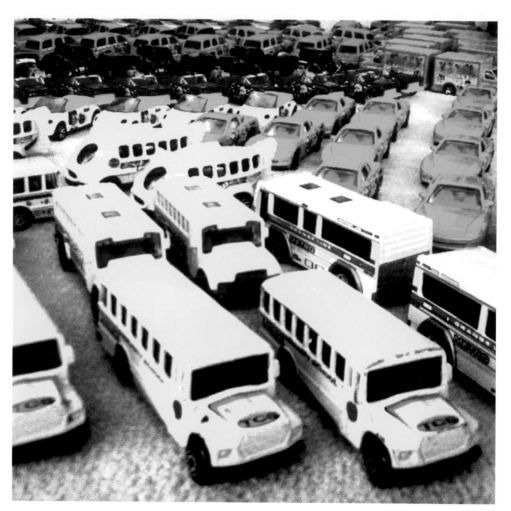

42 toy car collection, juneau

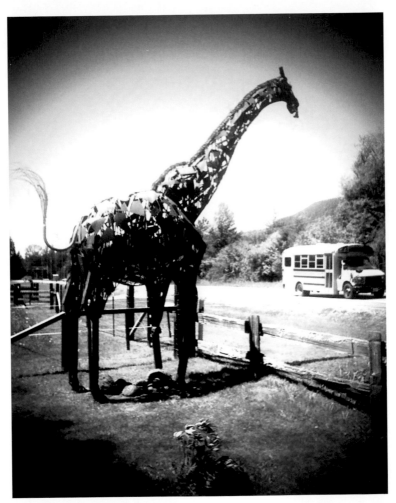

a giraffe and a school bus 43

The iPhone
can't do everything.

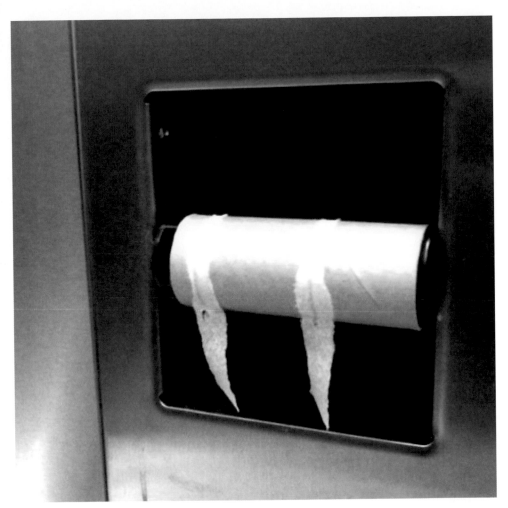

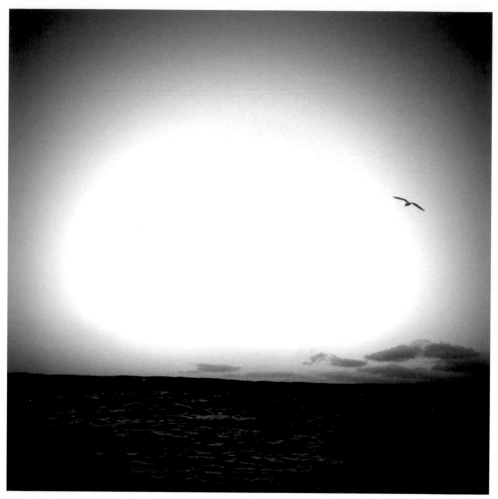

46 it's a bird

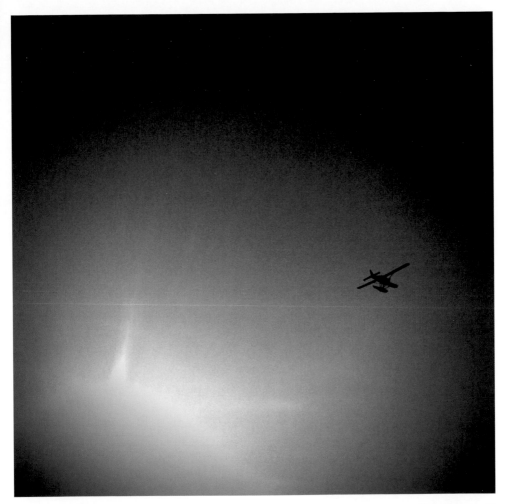

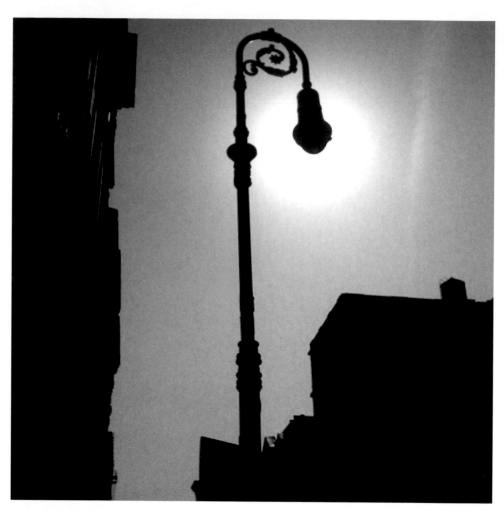

48 street lamp by day, nyc

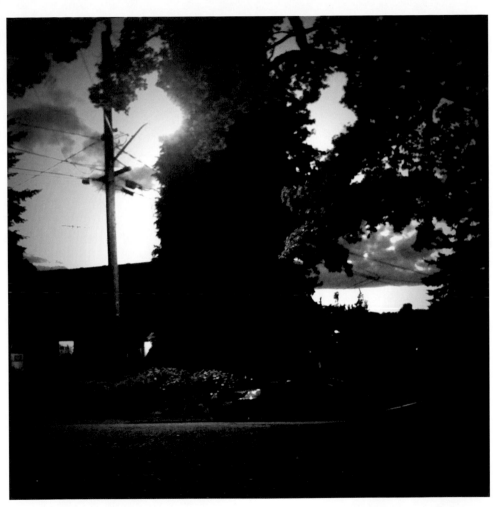

street lamp by night, seattle 49

50 speed limit

frost on my car 51

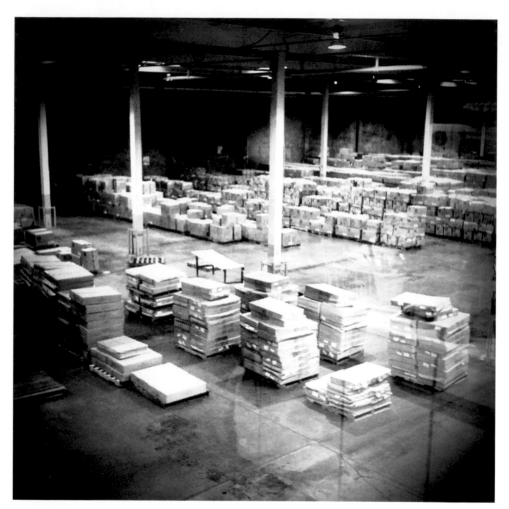

52 commodities, seattle

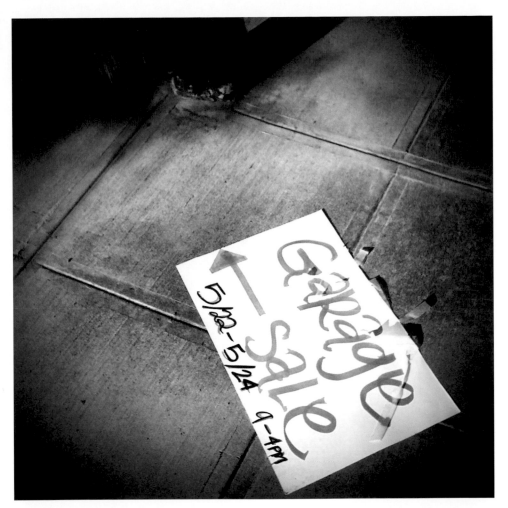

Garage
Sale
5/12-5/24 9-4pm

54 crusty boat hull

56 snail on a planter box

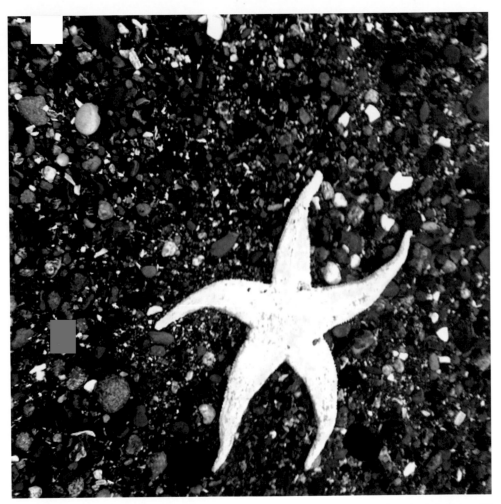

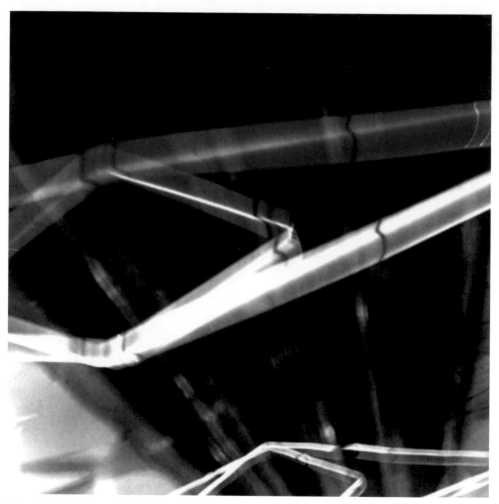

58 laser light show, o'hare

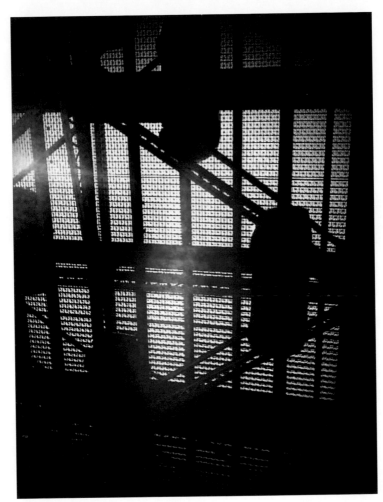

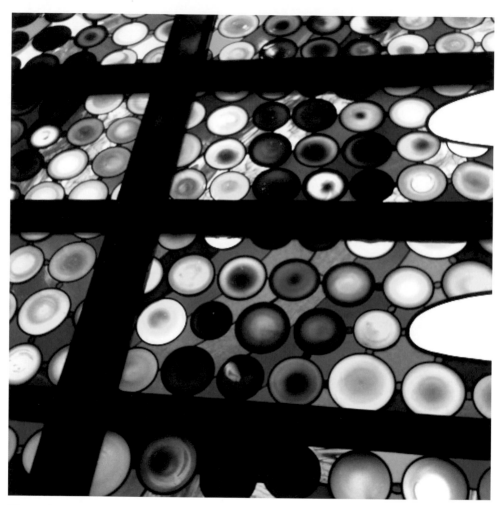

60 stained glass window, sea-tac airport

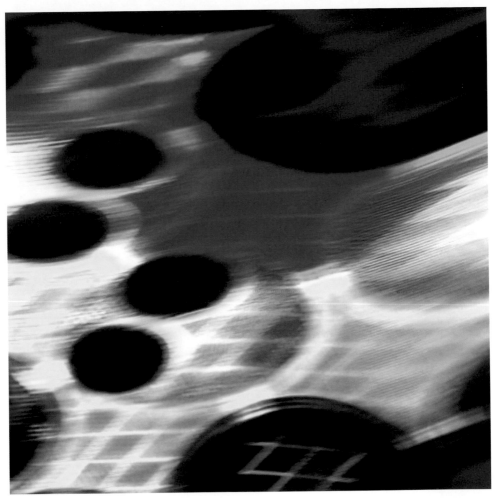

62 expired tabs, camano island

chalk mural, sydney 63

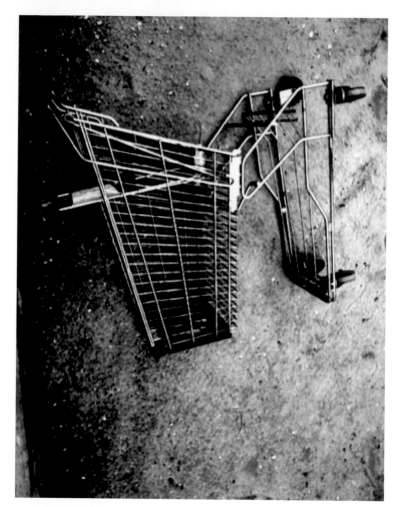

64 shopping cart fossil, dubai

The first time I went to Dubai,

it was at the apex of its out-of-control growth. Skyscrapers by the dozen going up like Lego castles. Bentleys, Gucci, industry everywhere. And a citywide attitude to match. A year later I returned and the city was paralyzed, in shock from the world-wide credit crisis. I spotted this shopping cart, discarded in the sand at Jumeirah Beach Park.

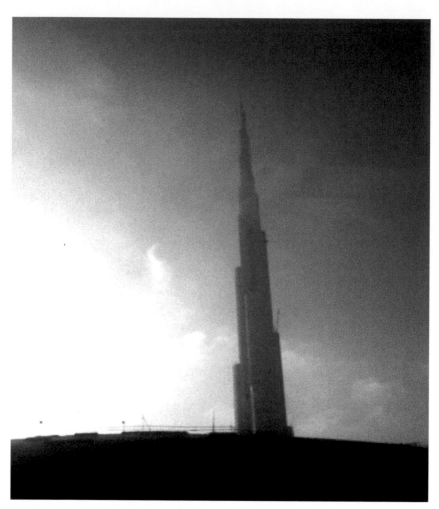

66 the tallest building in the world, dubai

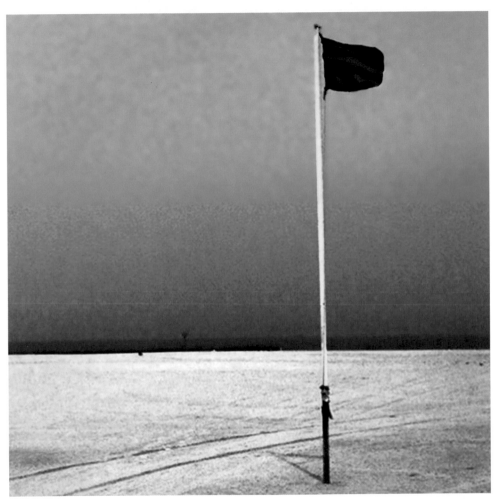

flag on jumeirah beach, dubai 67

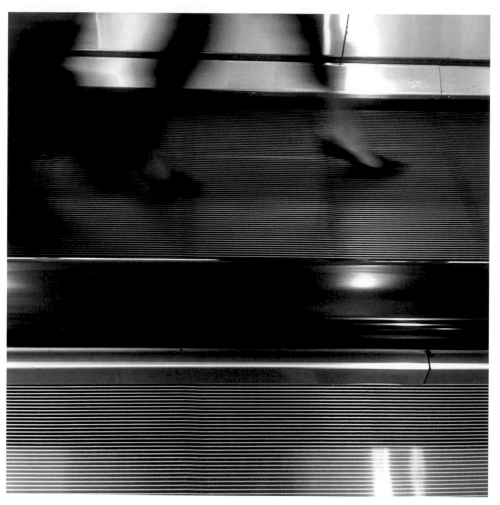

68 moving walkway, tokyo

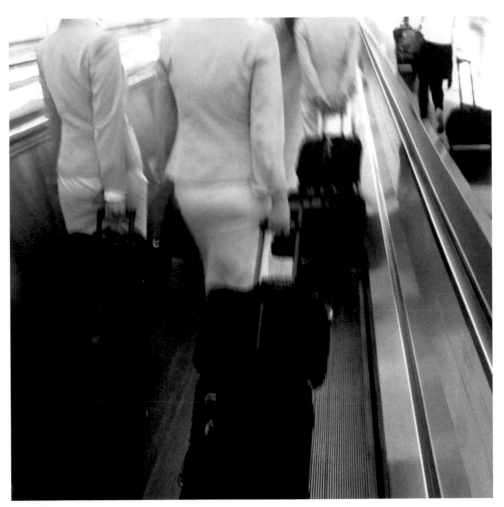

70 electric tea lights

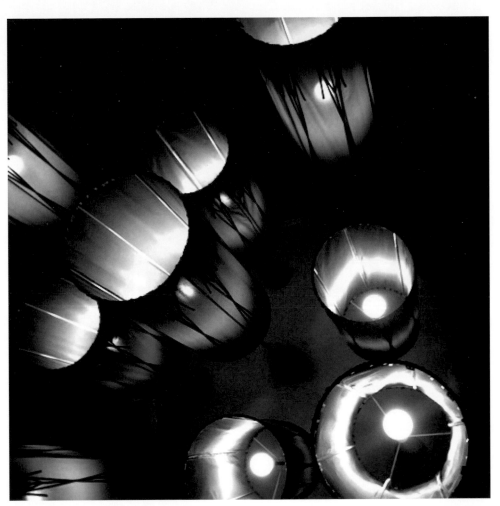

Each photograph is a
tiny invention.

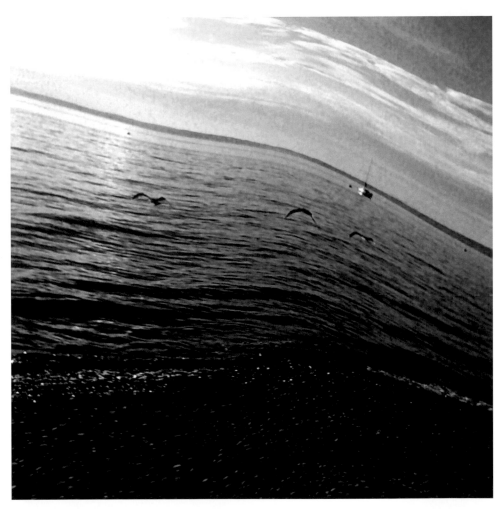

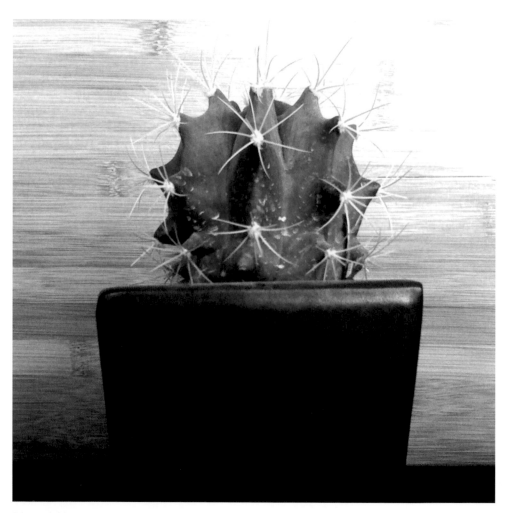

74 prickle

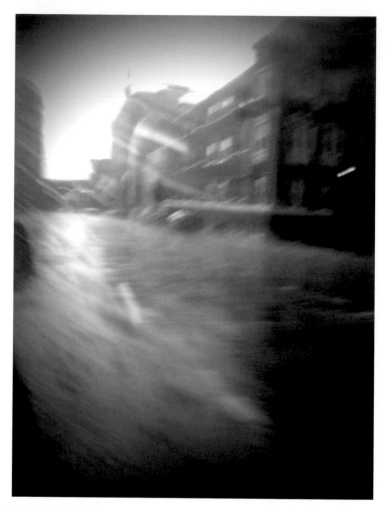

76 gumball-size hail, denver

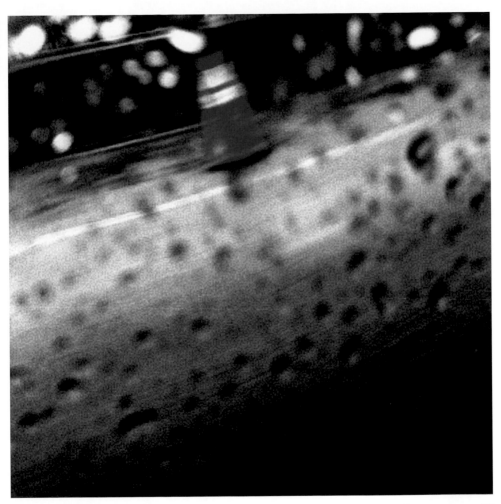

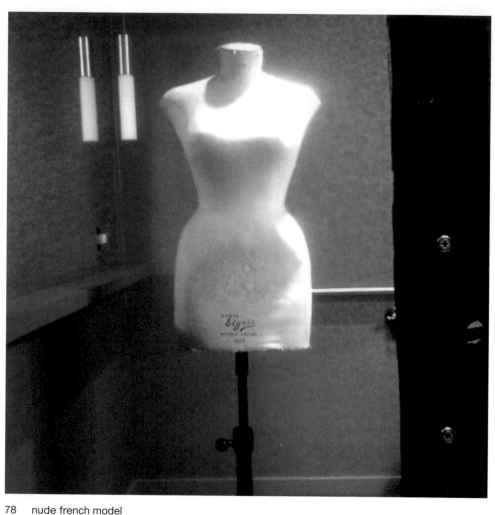

78 nude french model

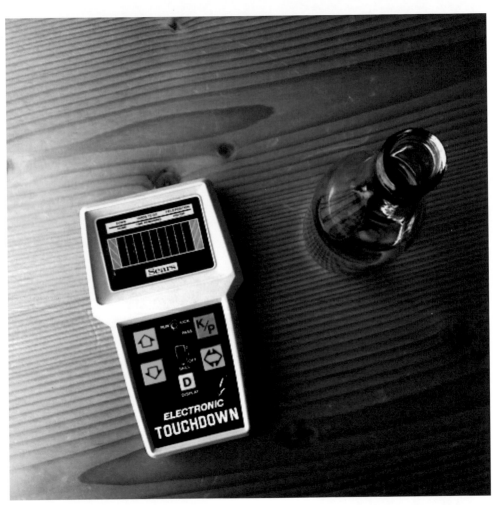

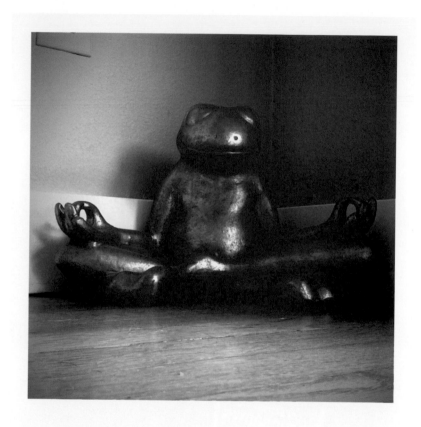

lotus frog

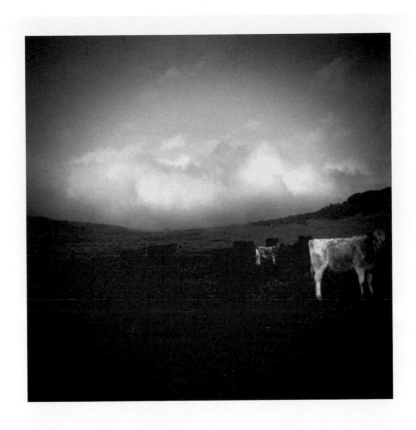

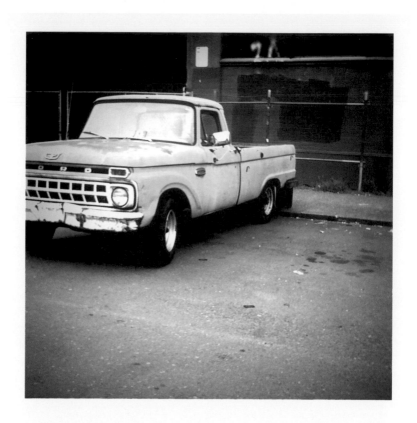

82 ford pickup truck

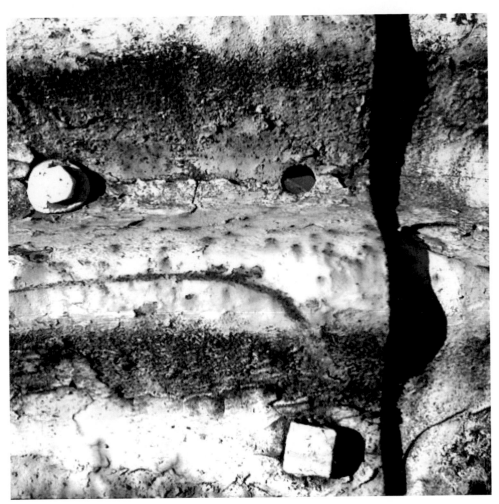

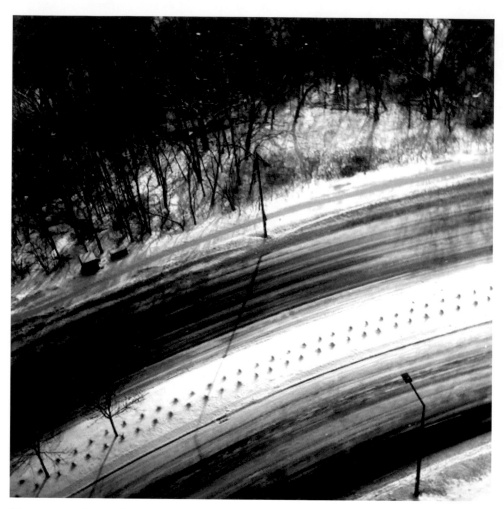

84　curves, minneapolis

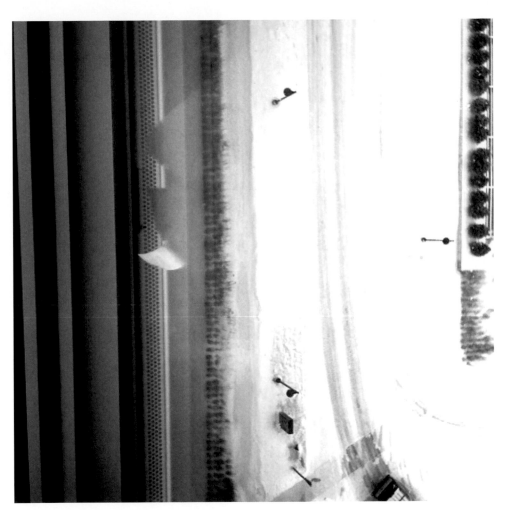

It's like a chef. He works all night serving Rare Moroccan Spiced Squab with Chermoula and Orange-Cumin Carrots. When he gets home, what does he make for himself?

A grilled cheese. Simple.

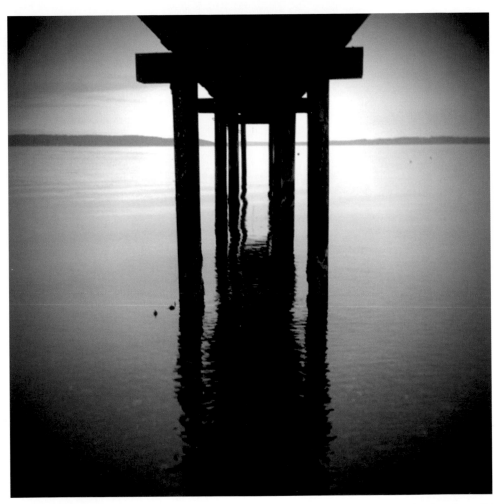

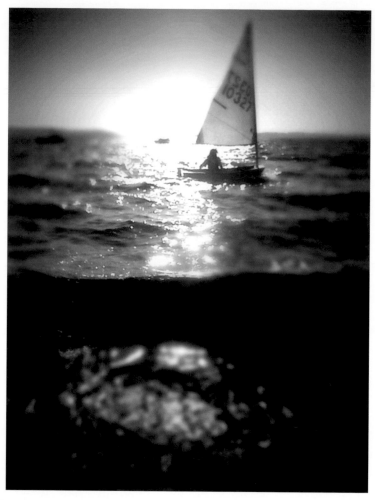

88 sunfish

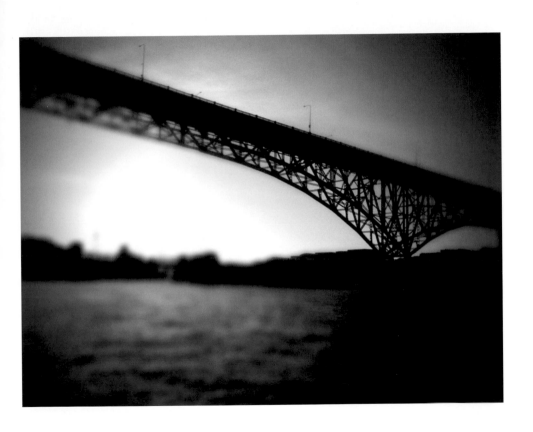

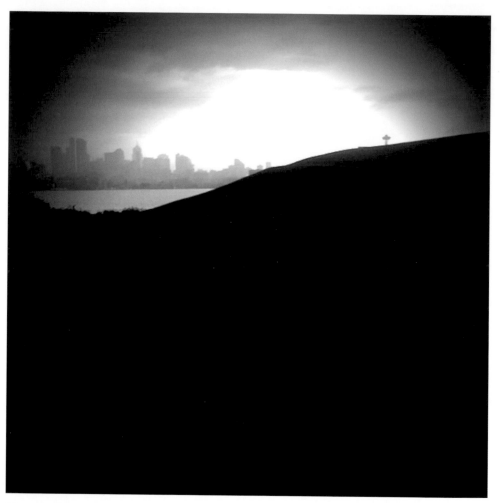

90 gasworks park, seattle

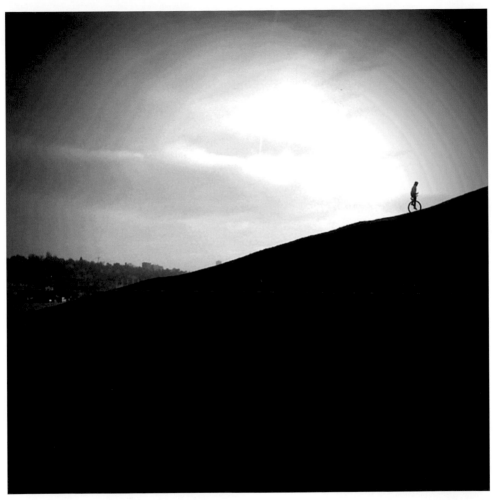

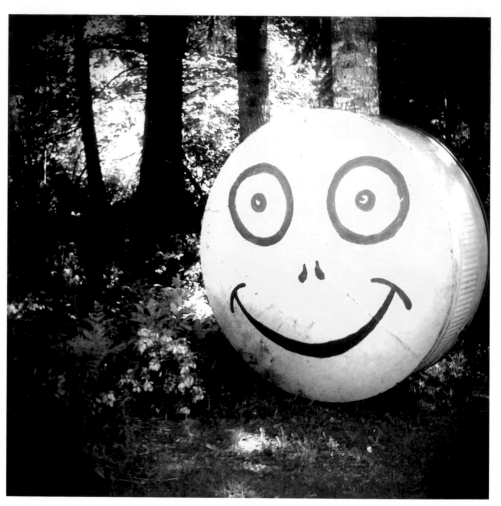

92 have a weird day

The moniker "creative person" makes it sound like I always know where my ideas come from.

I don't.

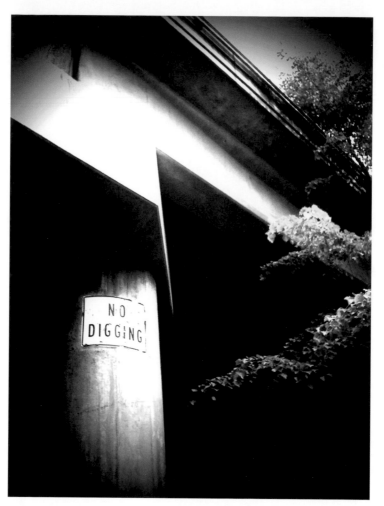

94 no digging

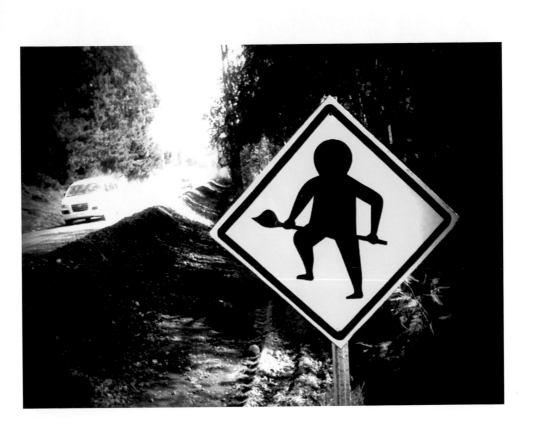

walking past a flowering hedge 97

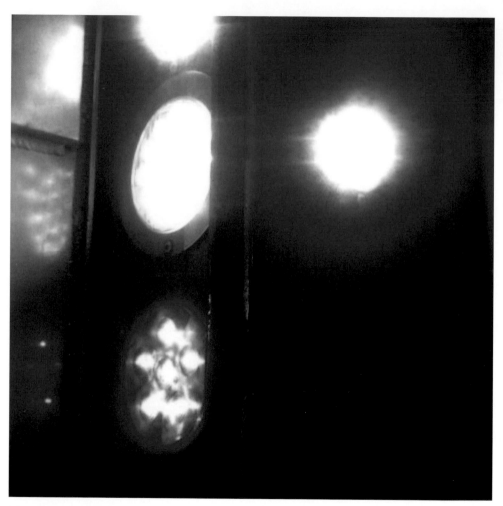

98 dump truck taillights

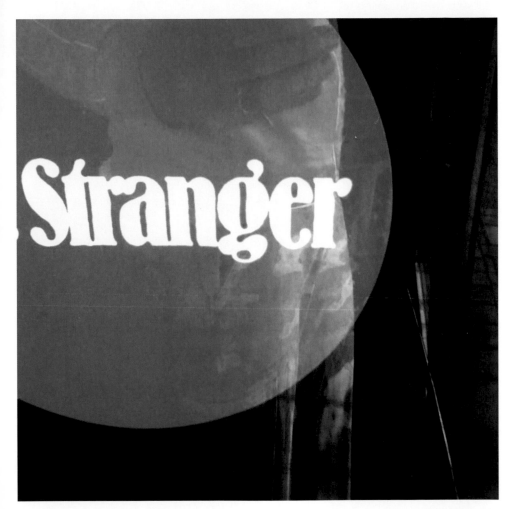

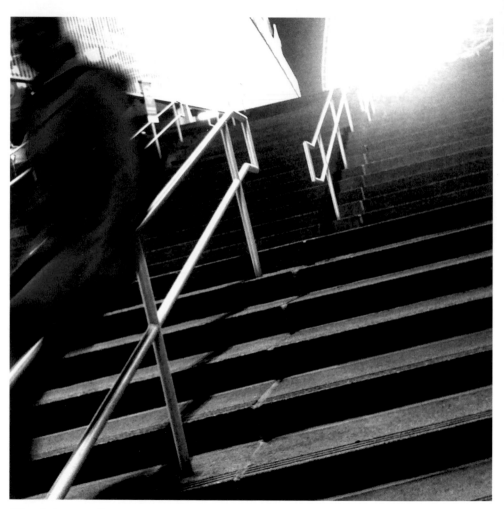

100 kate on a rail

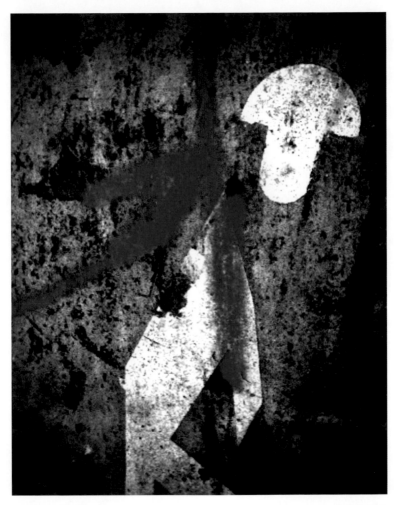

102 brunch on the road, leadville

106 vegan donut

108 10-speed shadow

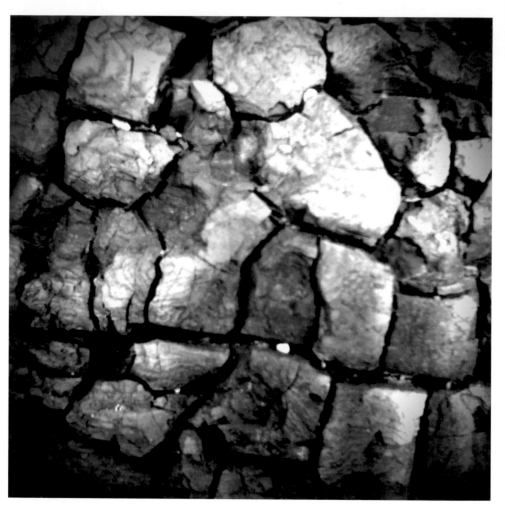

110 campfire remains

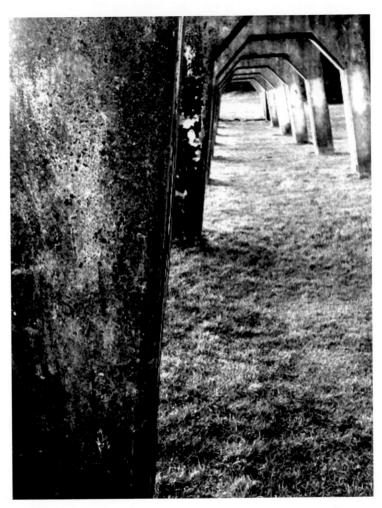

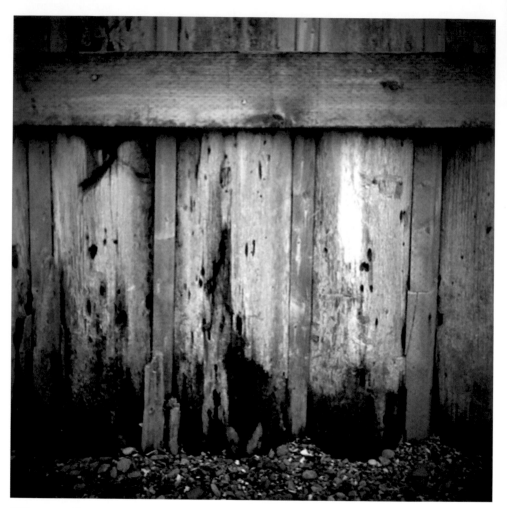

112 seawall

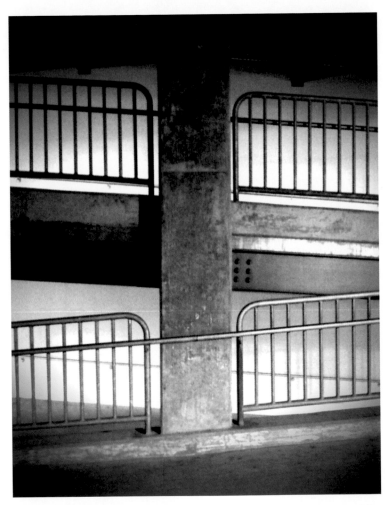

The gear you can't afford is not the barrier keeping you from success. Gear has
very little to do with photography.

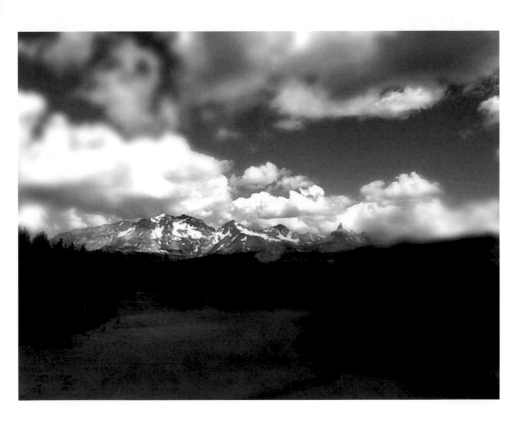

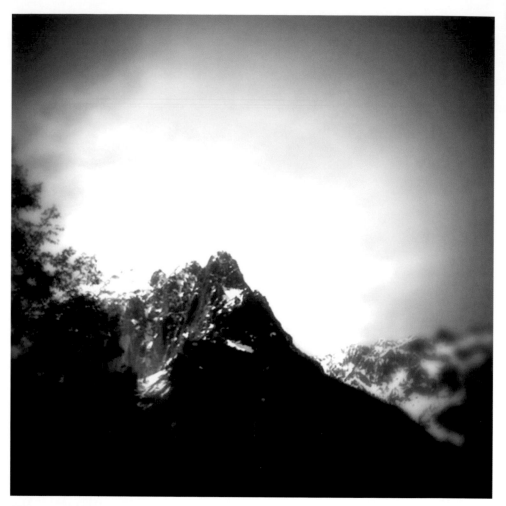

116 mount index

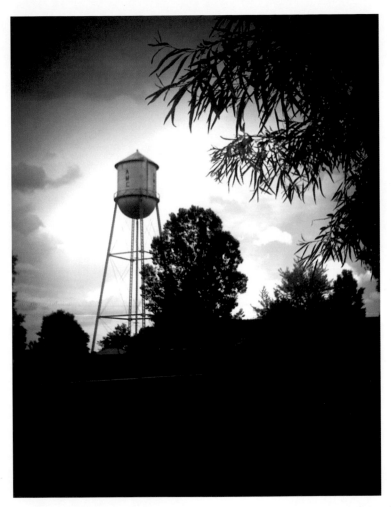

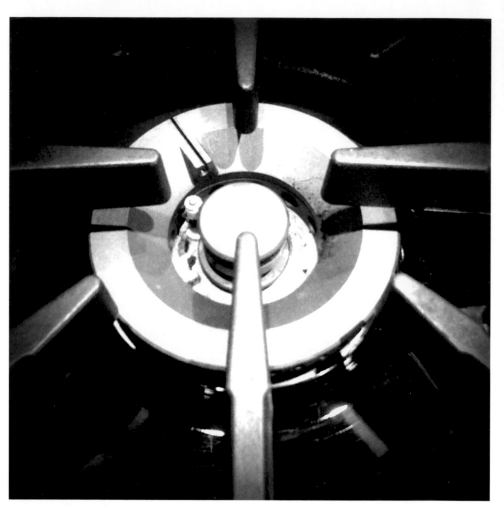

118 burner

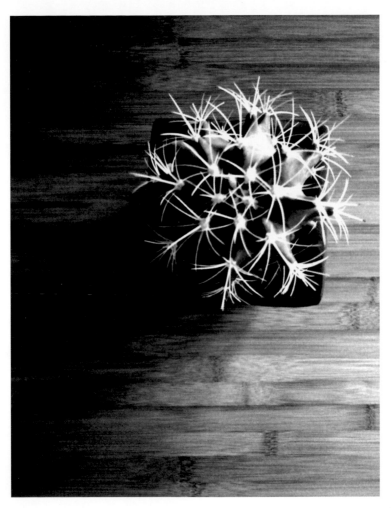

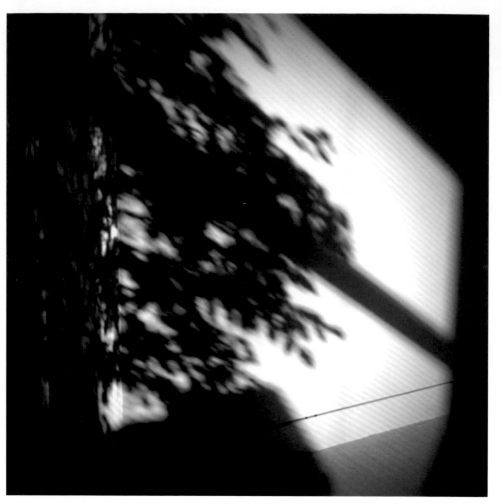

120 boardroom shadow

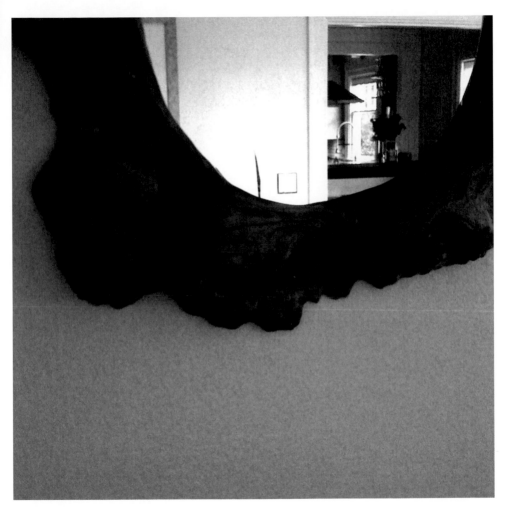

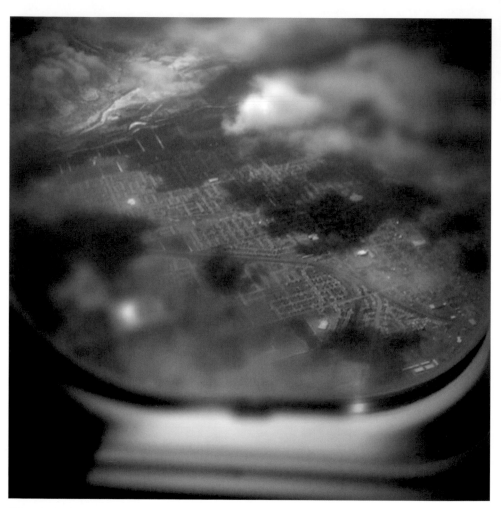

looks like the midwest

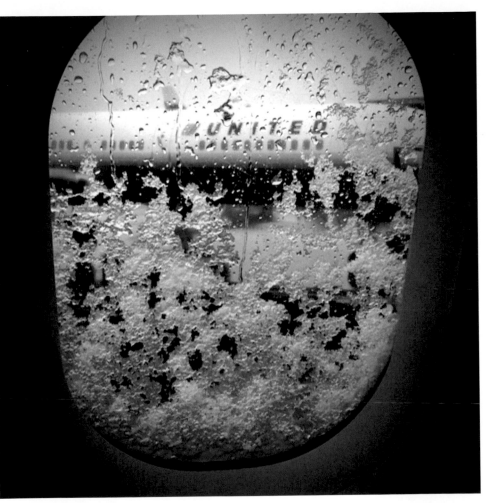

No longer do I tire

of the lounge or the crappy food or the painfully long lines at airports.

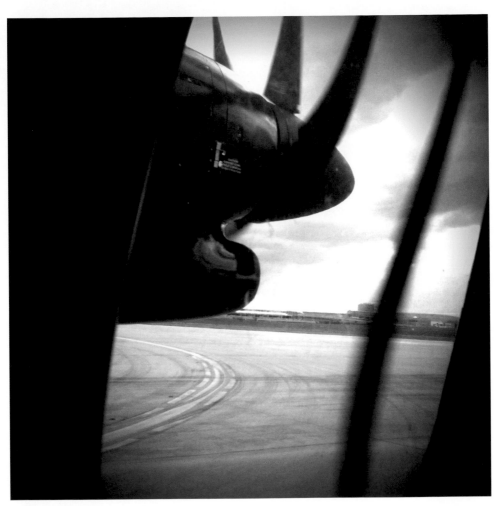

touchdown, denver 125

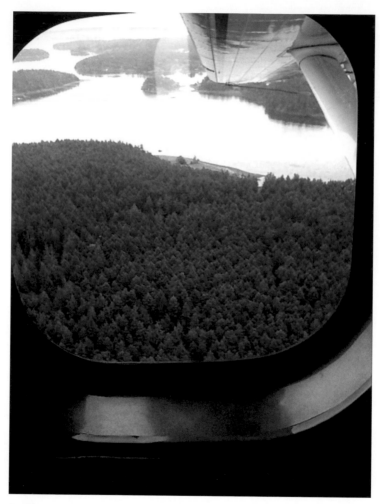

126 friday harbor

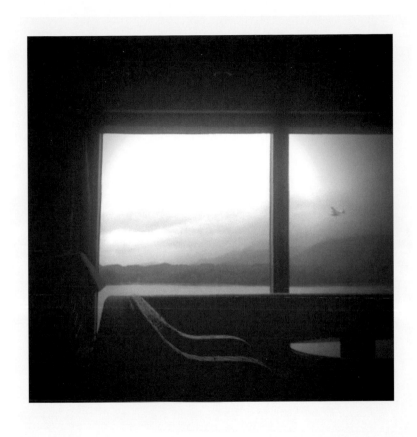

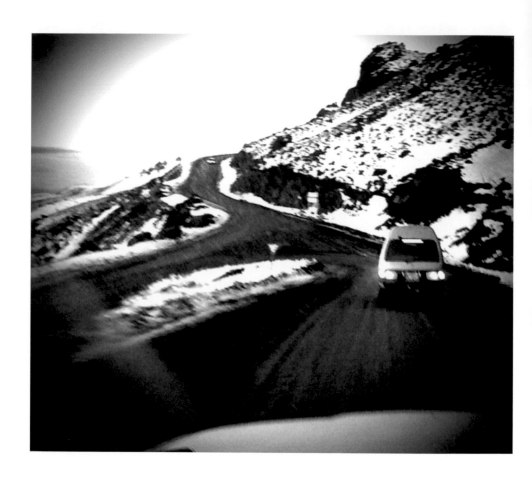

128 southern alps mountain pass, new zealand

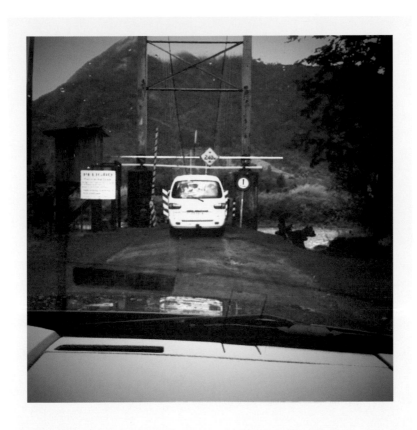

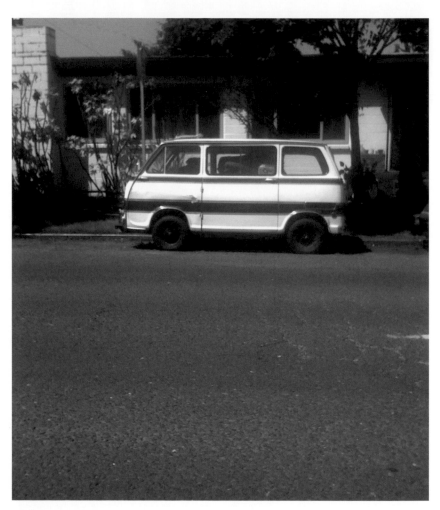

130 minivan

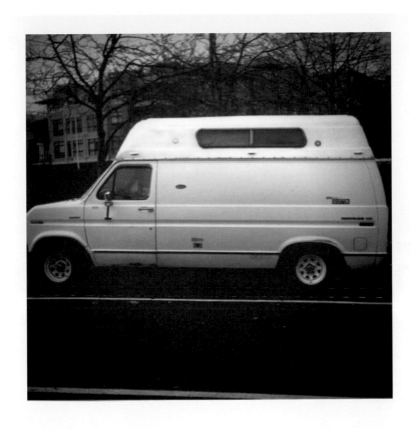

People usually ignore the camera that's built into your phone because they consider it useless.

That comes in handy.

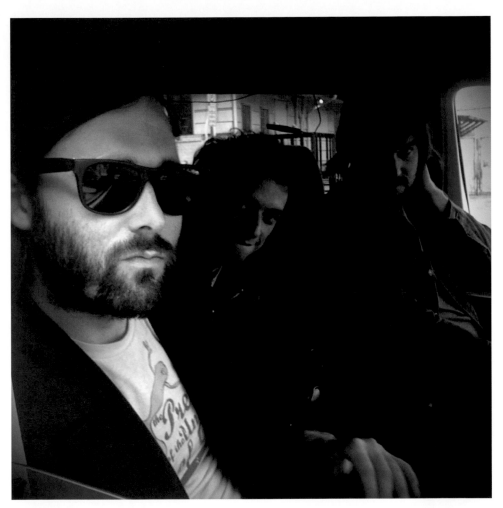

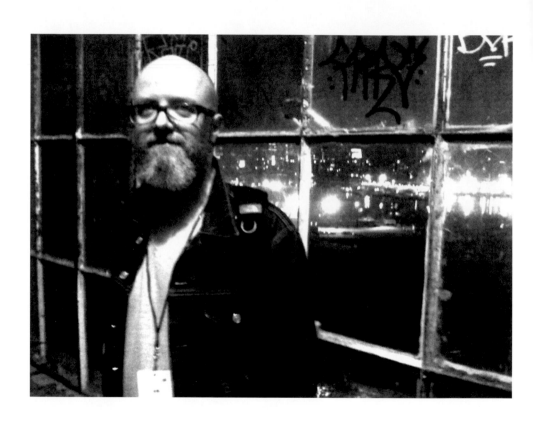

134 what's the jackanory, nyc

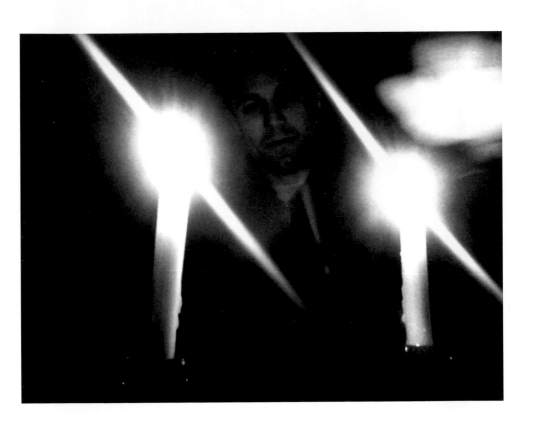

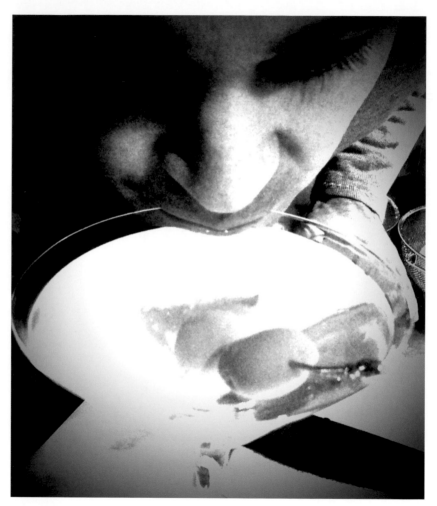

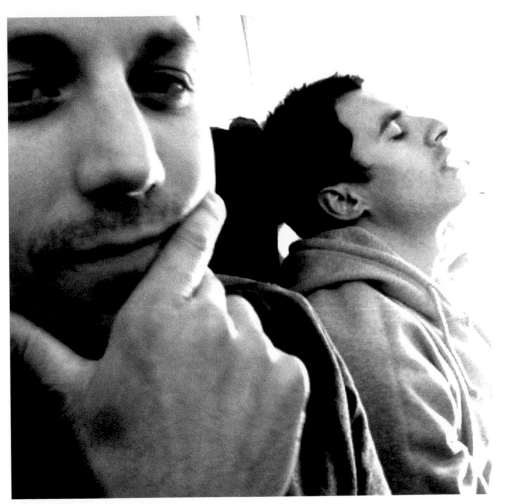

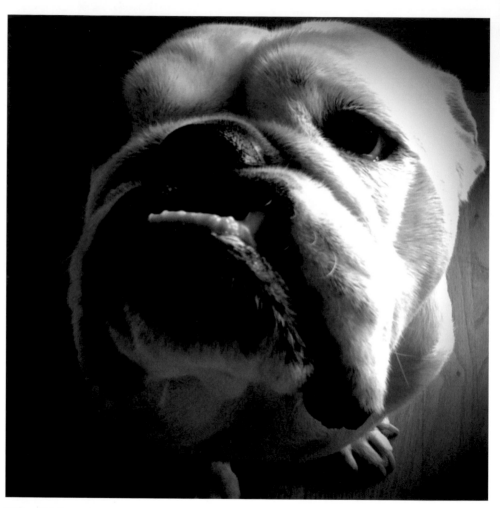

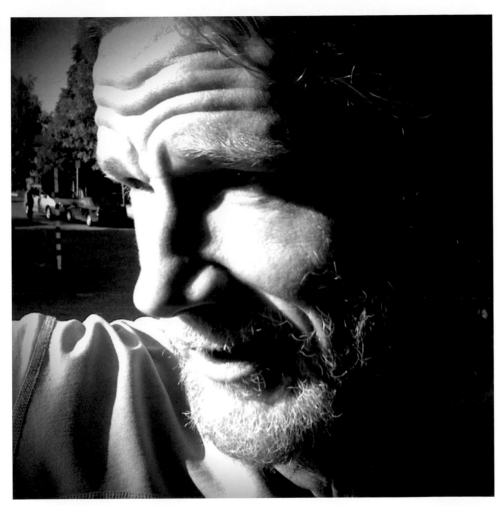

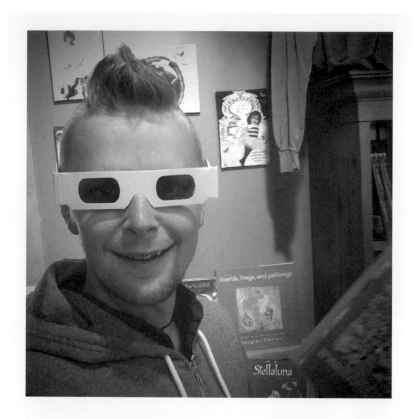

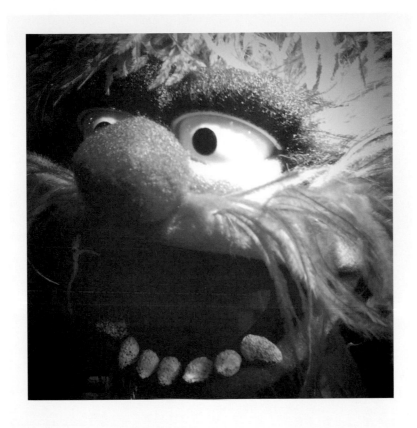

142 cropped

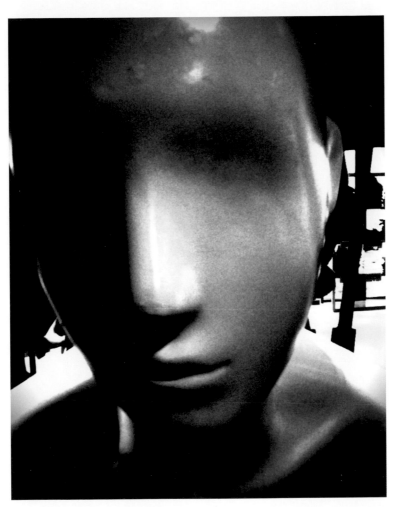

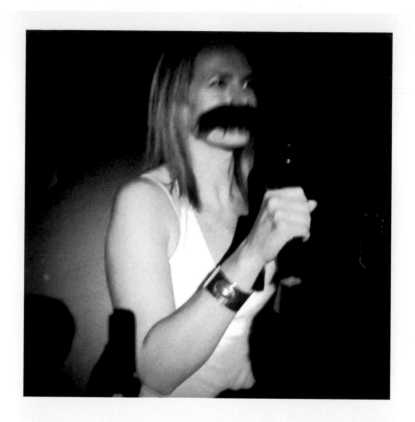

144 mustache karaoke

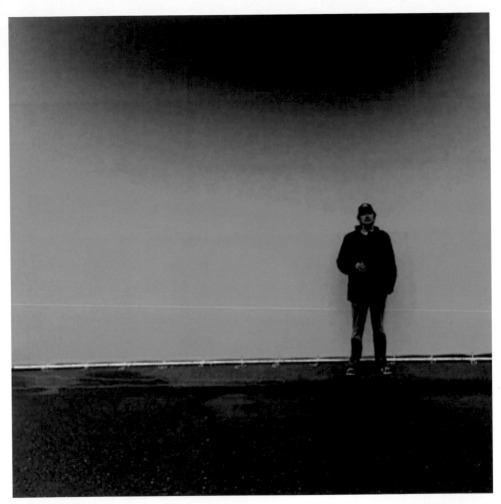

There are at least ten

great pictures waiting to be taken within ten meters of where you are standing right now.

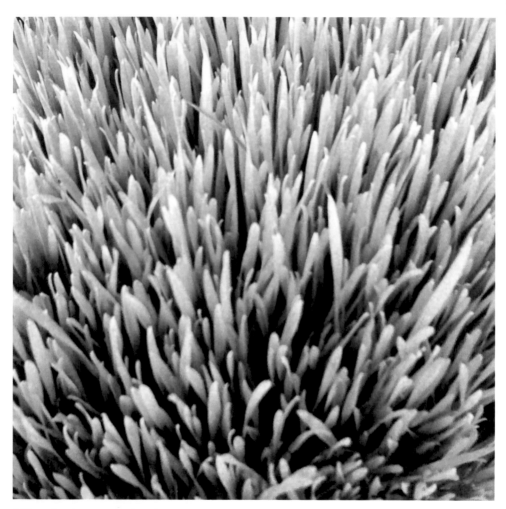

148 wheat grass, san francisco

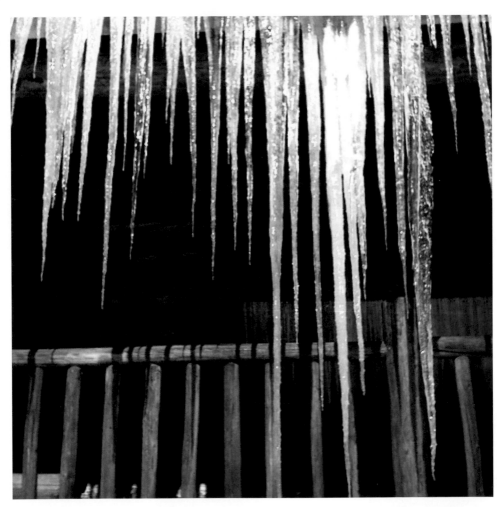

icicles, park city 149

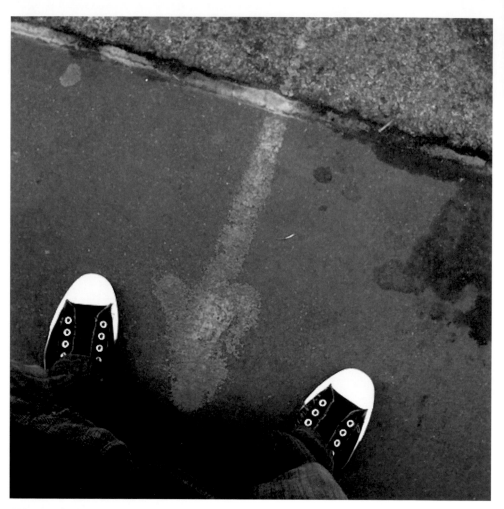

150 just looked down and noticed this, nyc

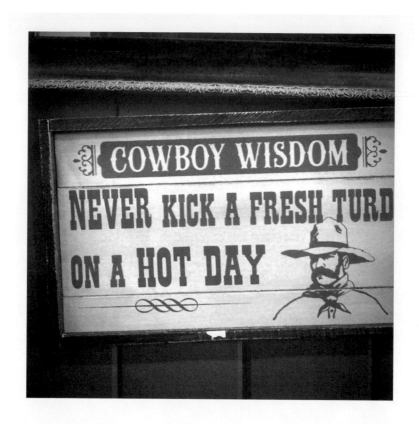

COWBOY WISDOM

NEVER KICK A FRESH TURD ON A HOT DAY

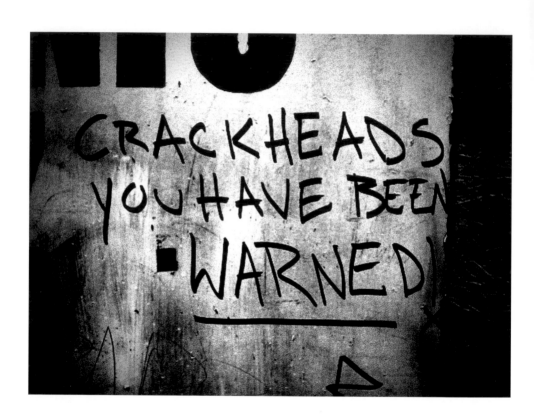

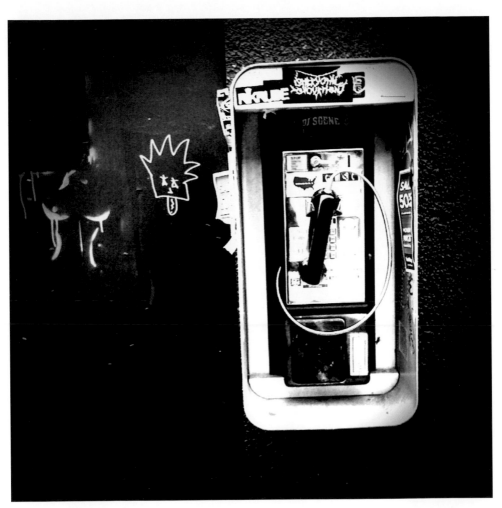

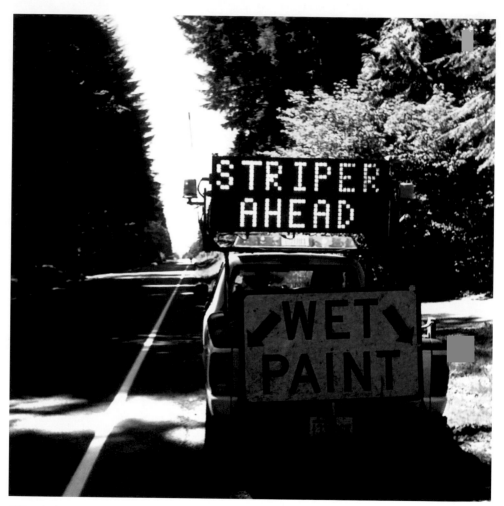

156 just missing one letter and then it would be really funny

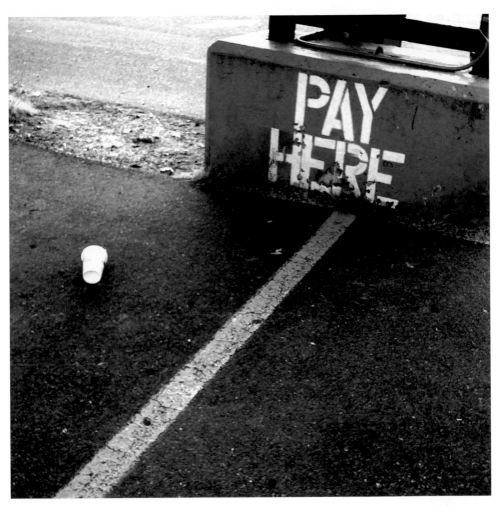

parking lot, seattle 157

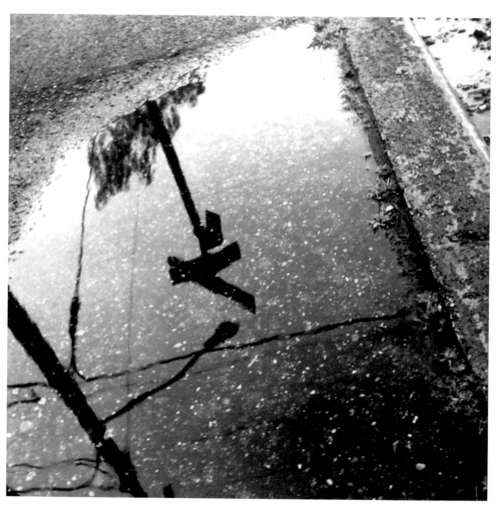

158 unsure which way is up

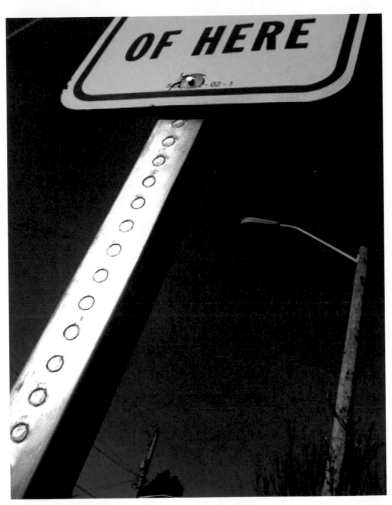

place of origin, seattle 159

I edged myself out over the pool from a balcony to grab this shot, and then I watched my sunglasses

disappear with a splash.

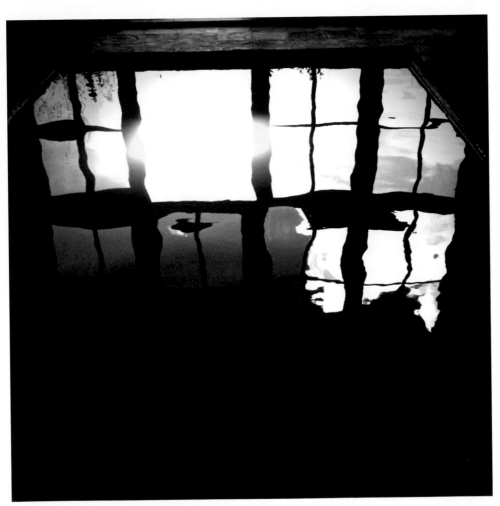

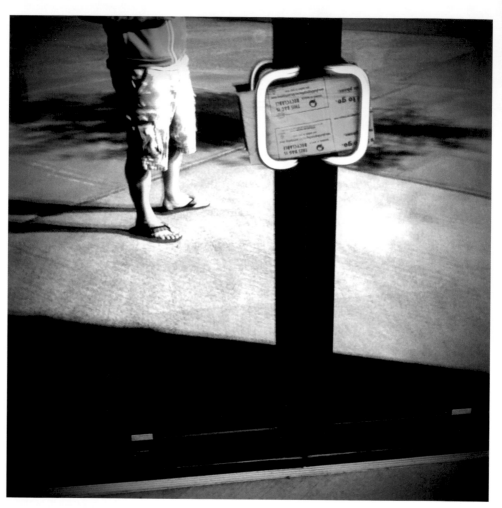

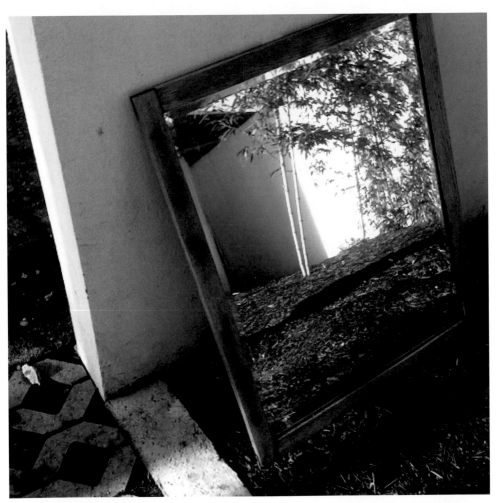

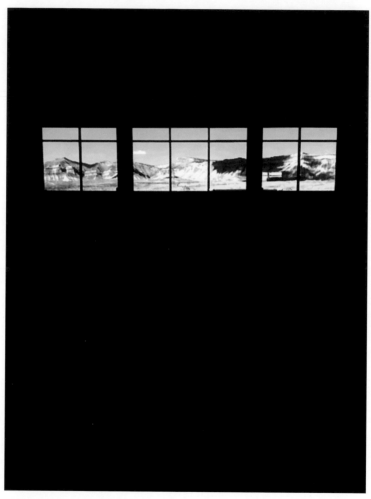

164 airport windows, grand junction

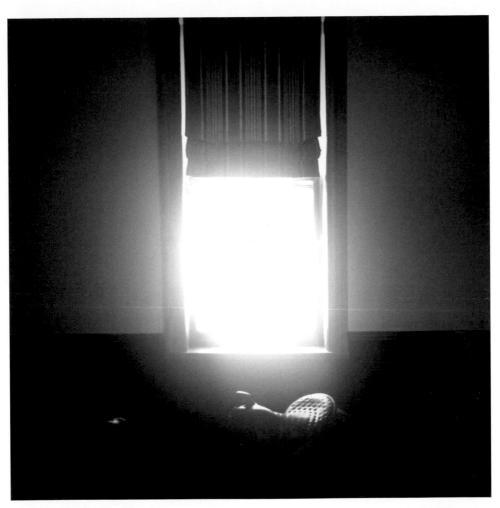

I was on location in Pucón, Chile. Instead of shooting, I was stuck indoors during a weeklong downpour. In turn, I down-poured local beers, ate the strangest bar-snack mix of my life (which destroyed my breath), and played endless racquetball on courts built in the early '80s.

In that order. Every day.

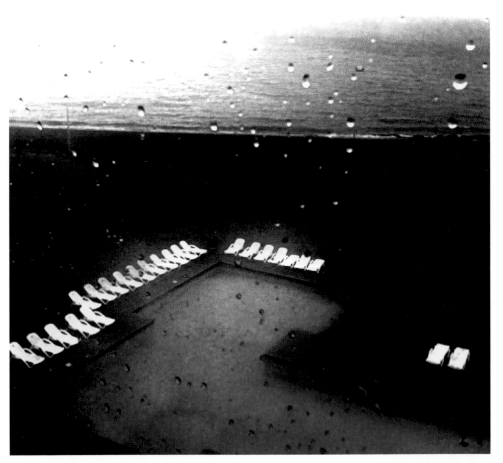

When you're bogged down,

play.

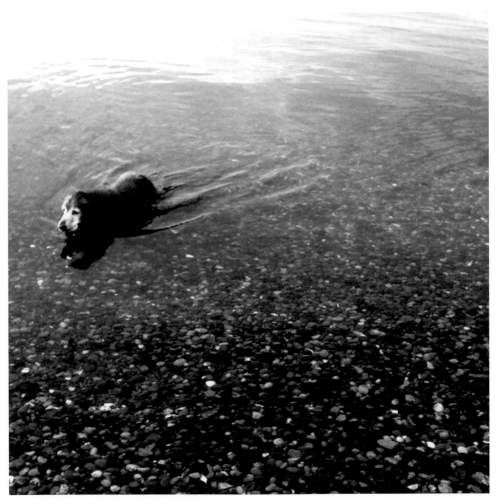

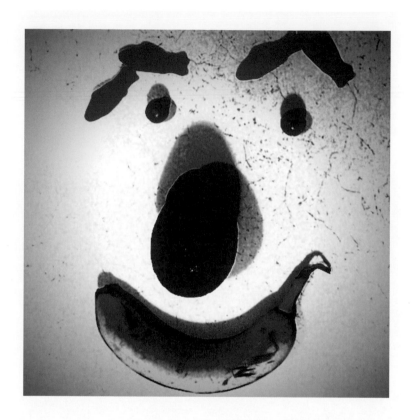

170 i would pluck the eyebrows

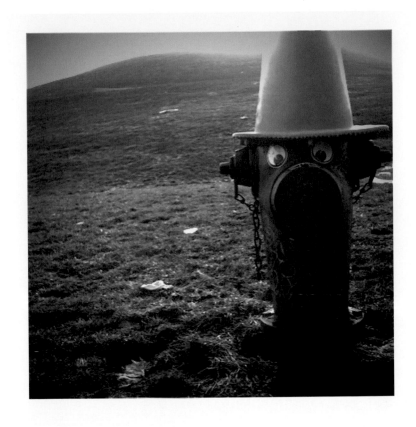

stumbled upon a conehead 171

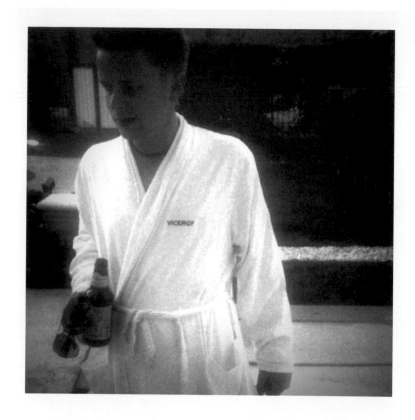

172 cody on sunday morning, palm springs

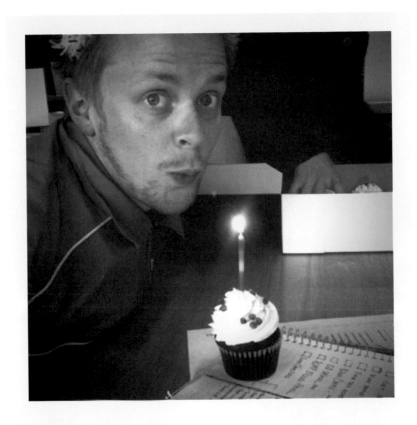

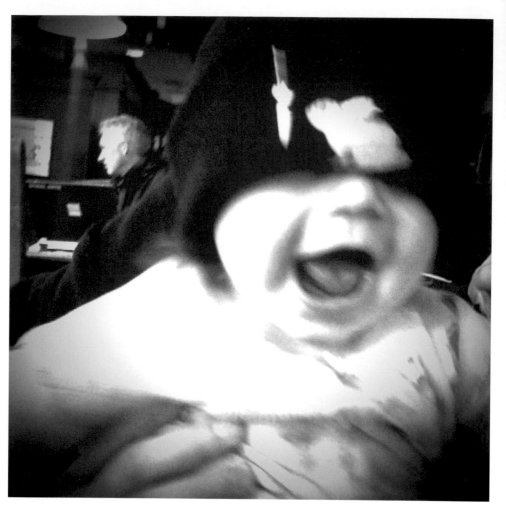

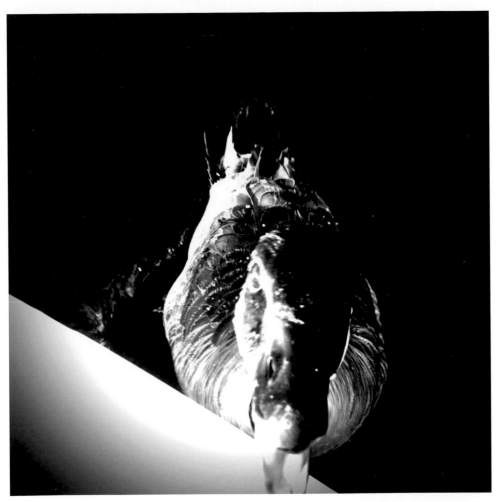

if i only had that new 'bread' application

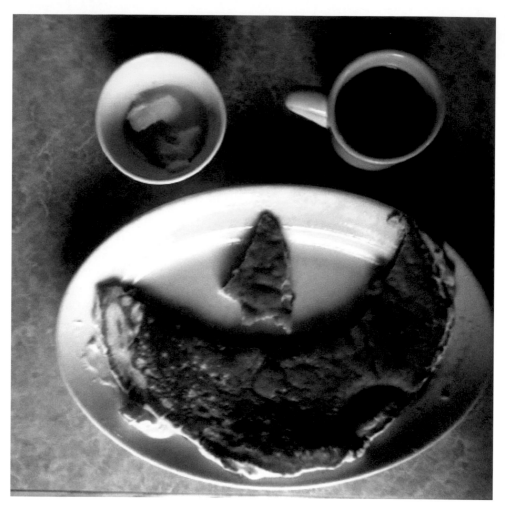

176 favorite meal of the day, vashon island

The *before* shots

are sent to foodie friends. The *after* shots are almost always of some horrendous mess I've made at the table, or some cheeky sculpture I've created from my leftovers.

bunny and goose 179

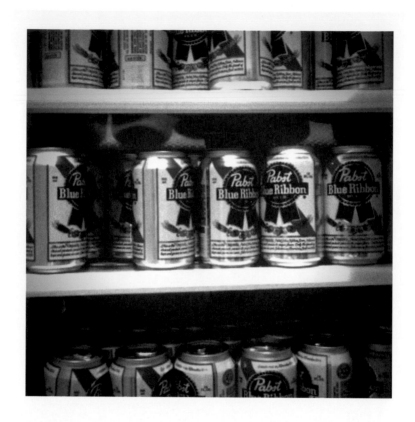

182 selected as america's best beer in 1893

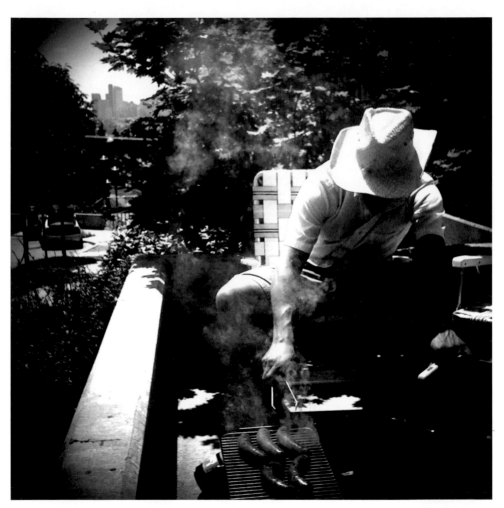

I got lost the other day in NYC.
I just got out of a cab somewhere on the Lower East Side, and I didn't read a single street sign. I wandered and took pictures until my iPhone ran out of batteries.

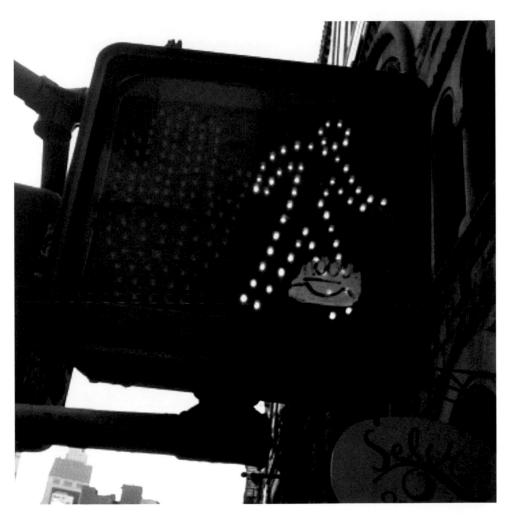

186 headline in a gutter, nyc

188 heels on subway station floor

converse on moving walkway 189

190 heels on white

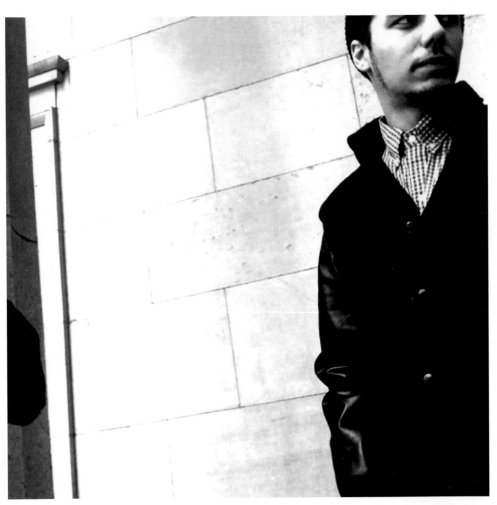

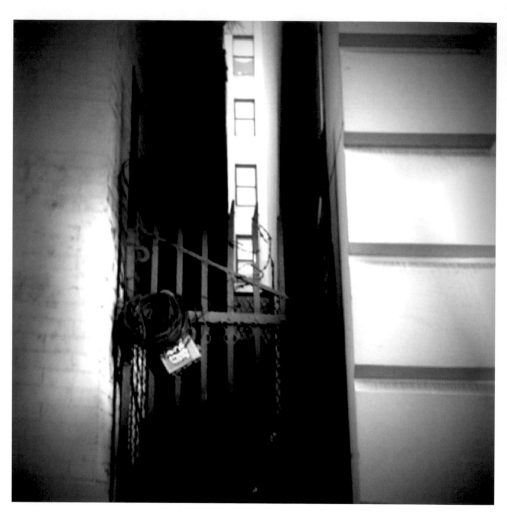

192 narrow alley with barbed wire, nyc

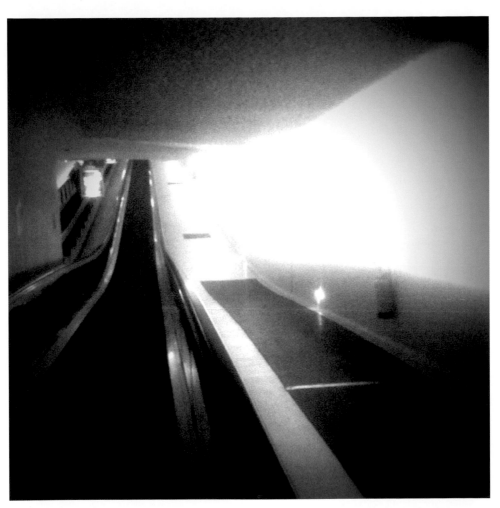

charles de gaulle, paris 193

This
is more than a project.

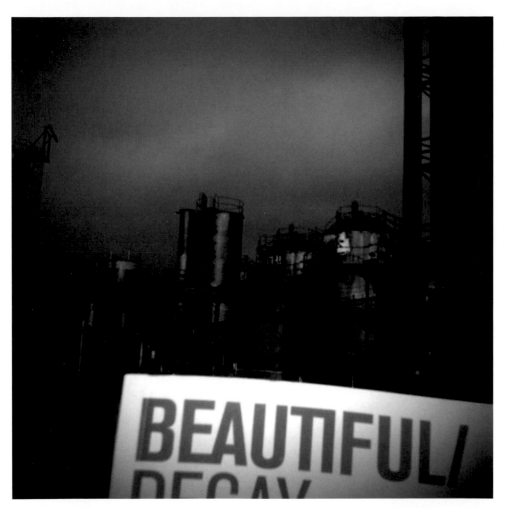

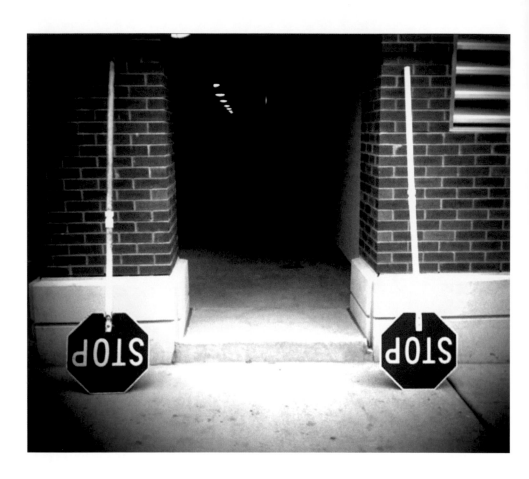

196 inverted stop signs, boulder

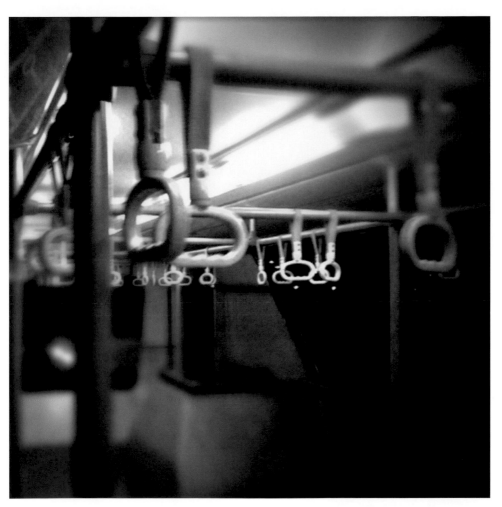

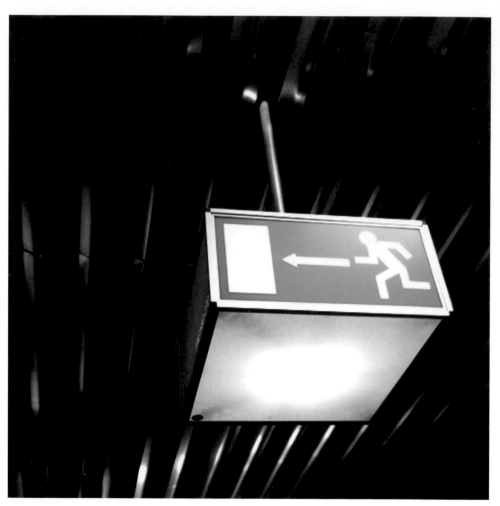

198 running man, frankfurt

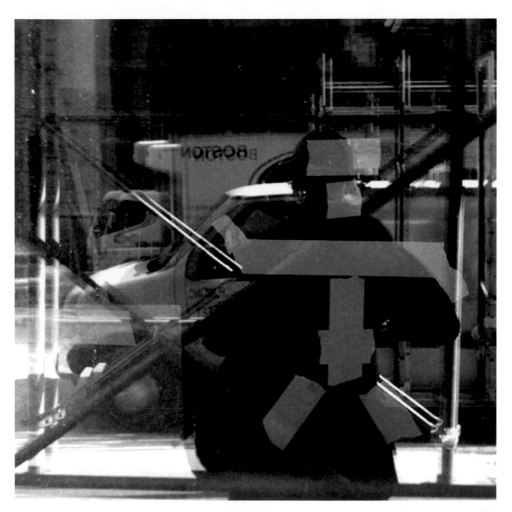

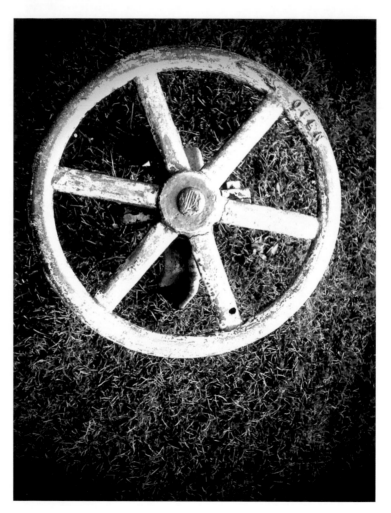

200 drive

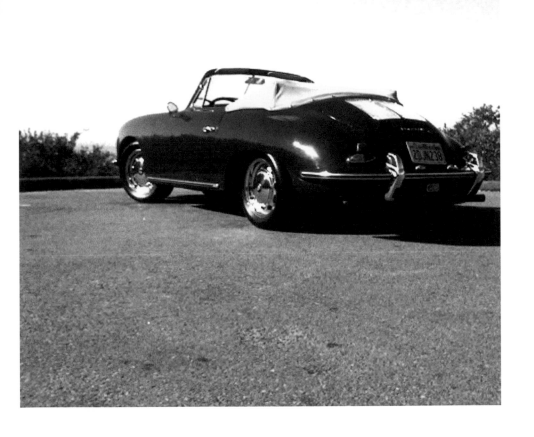

We came around a corner and met a cloud of dust, a couple hundred feet of skid marks, and a mostly upside-down VW in a ditch. No other cars in sight. We pulled over, called 911, and jumped out of the car just in time to watch the driver kick his way through a shattered sunroof.

There's an old adage in photojournalism: "f/8 and be there." Now we don't even have to **remember the "f/8" part.**

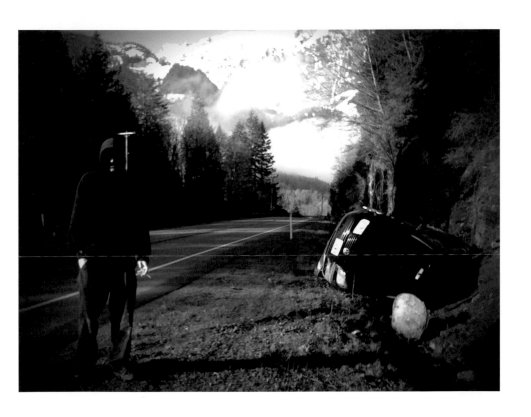

The dirtiest secret

in photography: shoot a hell of a lot of pictures to get the ones you want.

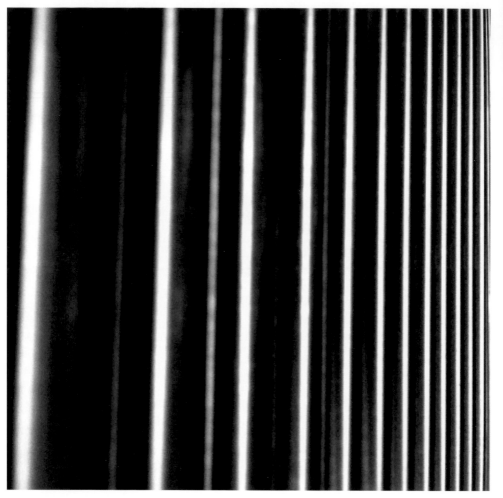

206 louvers

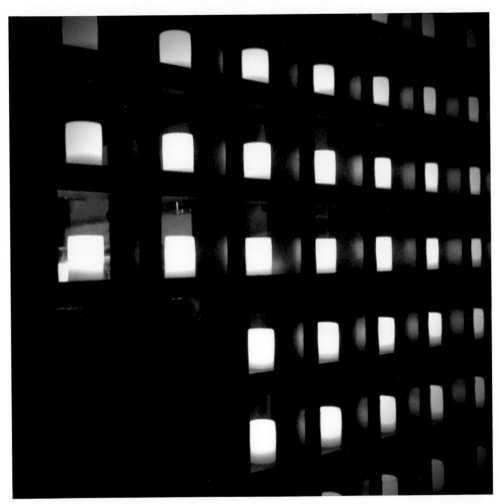

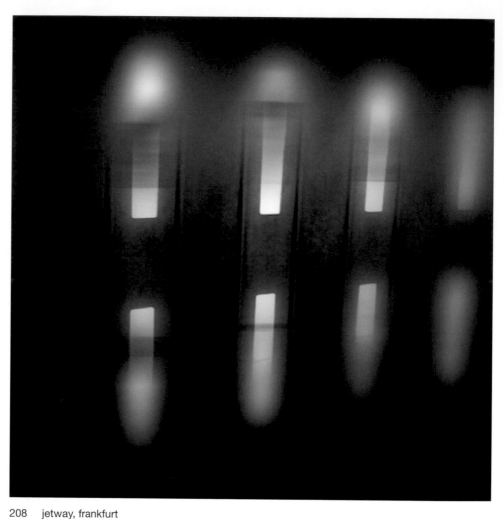

208 jetway, frankfurt

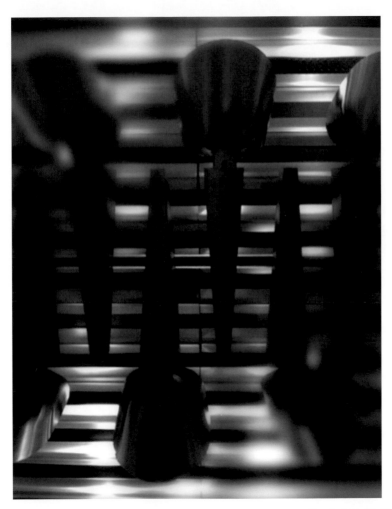

If you don't think you can take a picture of something with a certain camera,

you're playing by the rules.

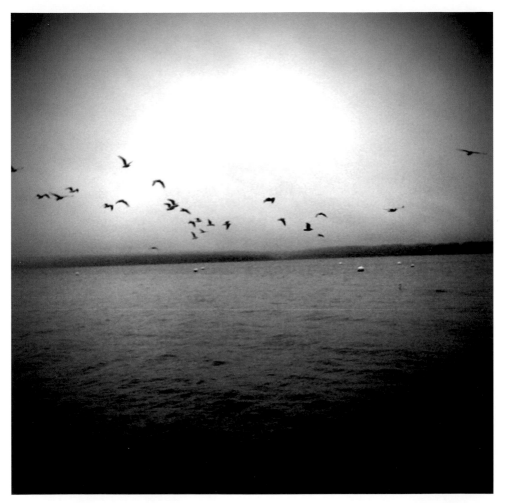

gulls in flight, puget sound

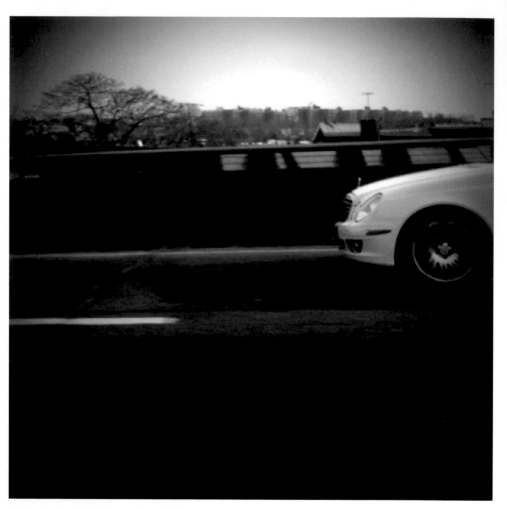

212 mercedes with a rolling shutter

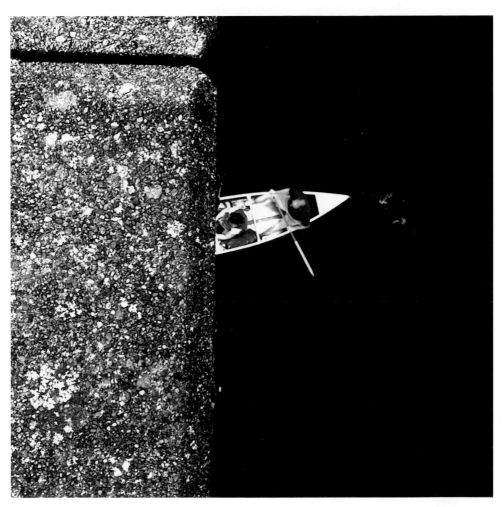

sometimes an image only tells half the story 213

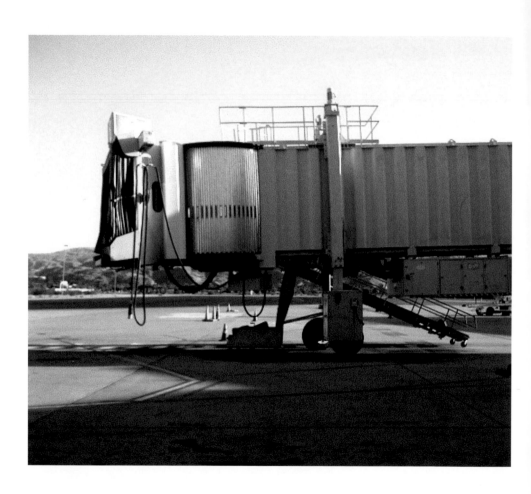

214 jetway, palm springs

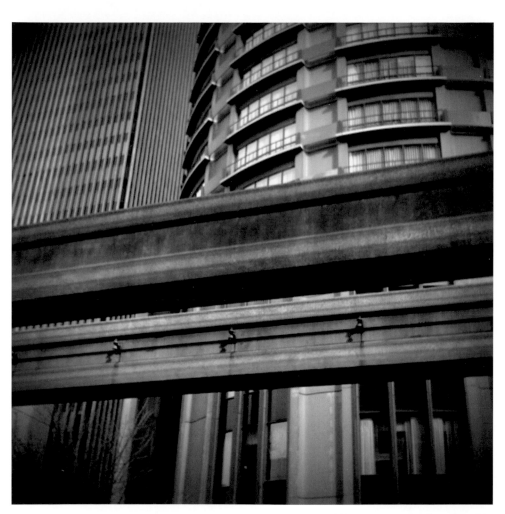

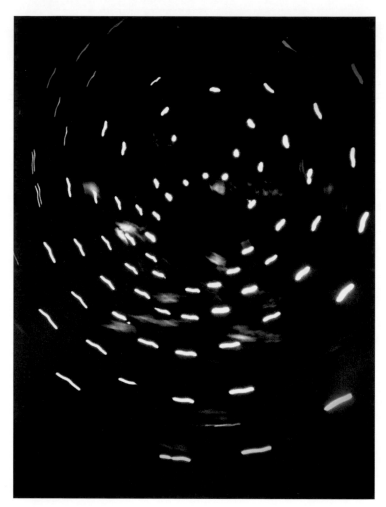

216 looking down on uplights

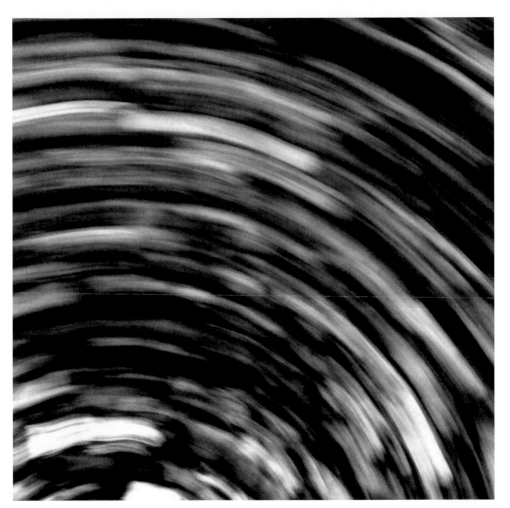

218 inverted sunset

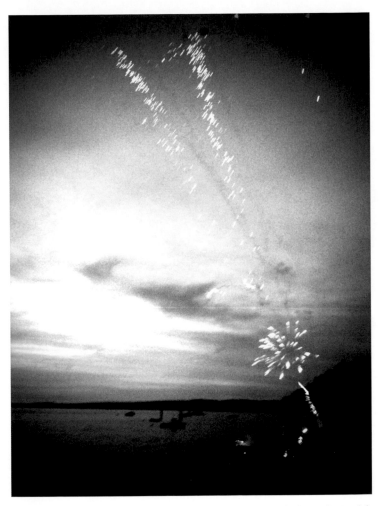

220 red pulley

sea foam 221

Some pictures tell stories.
Others ask questions.

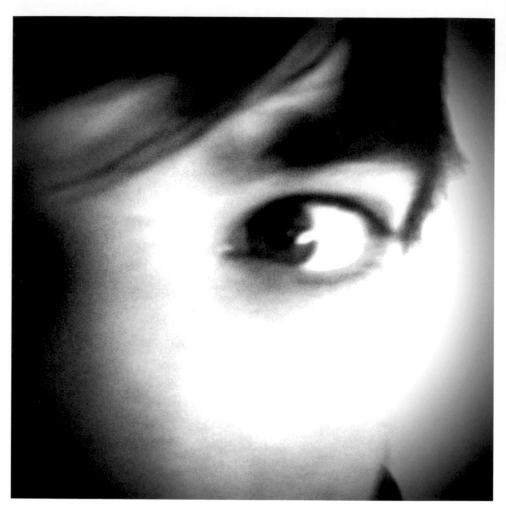

224 retinal scan, los angeles

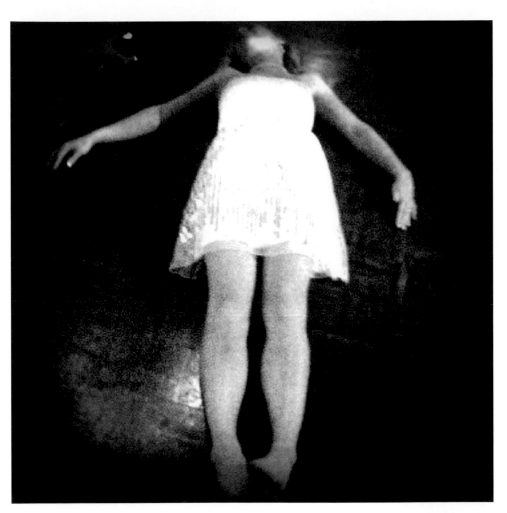

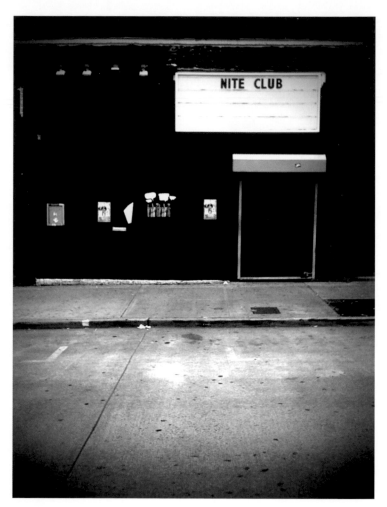

226 party

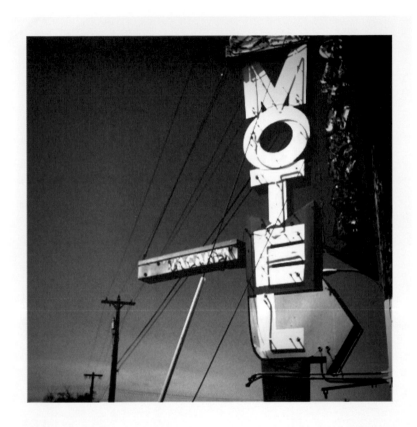

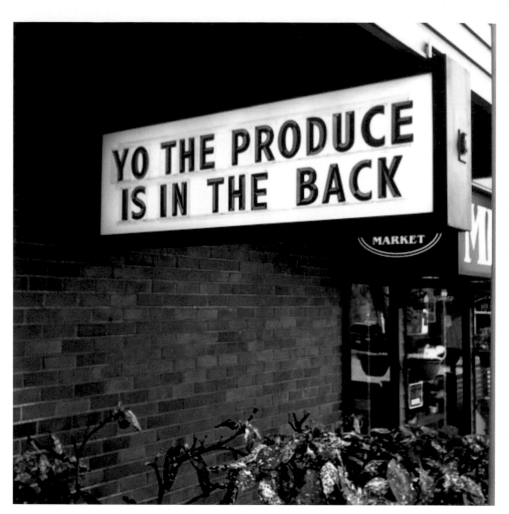

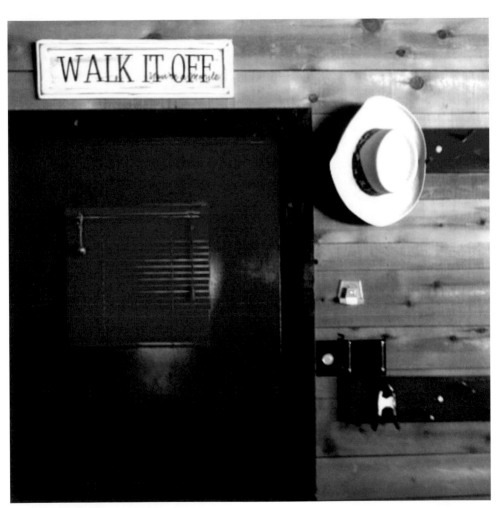

Every photographer takes crappy pictures, every painter paints crappy paintings, and every actor blows their lines. What really matters is that you're out there,

sending stuff into the world.

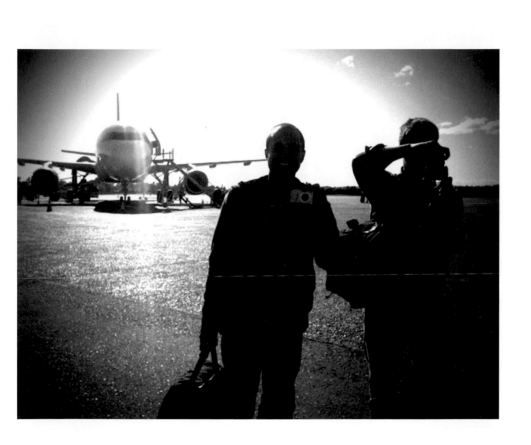

mario and scott, new zealand 231

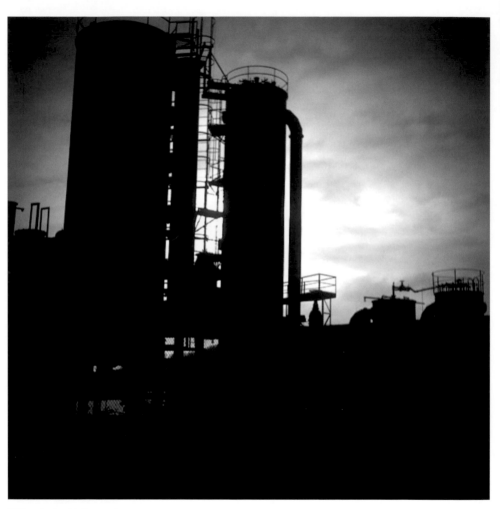

232 industrial complex

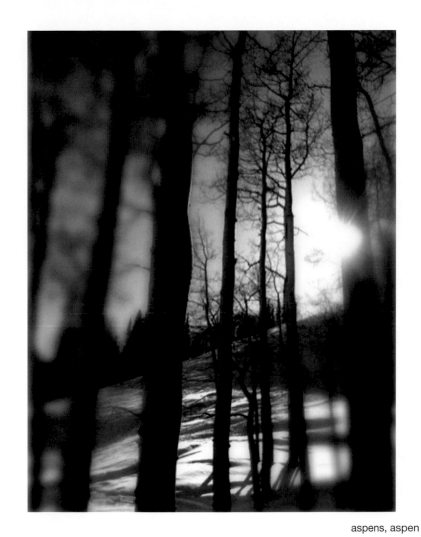

234 five o'clock shadow

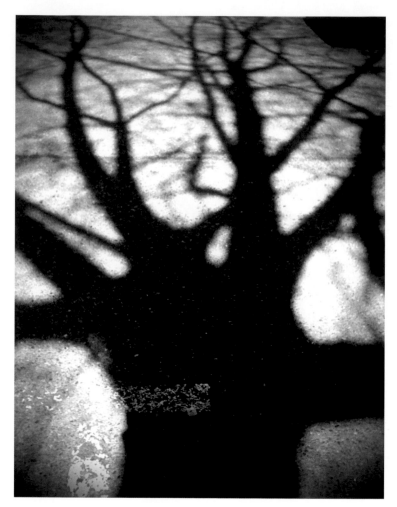

236 tree shadow on roadway

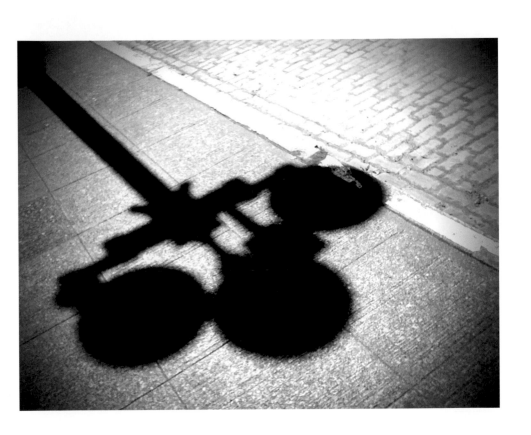

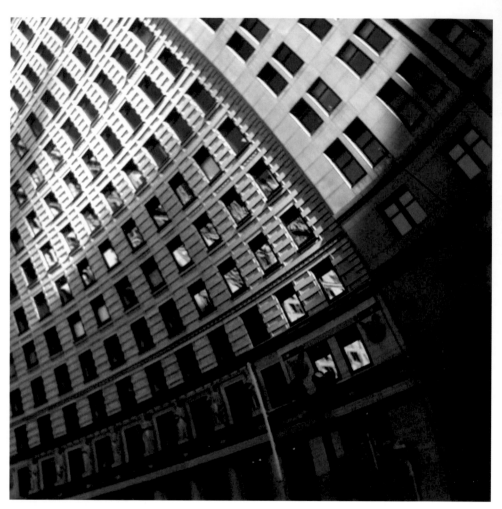

238 altered states, nyc

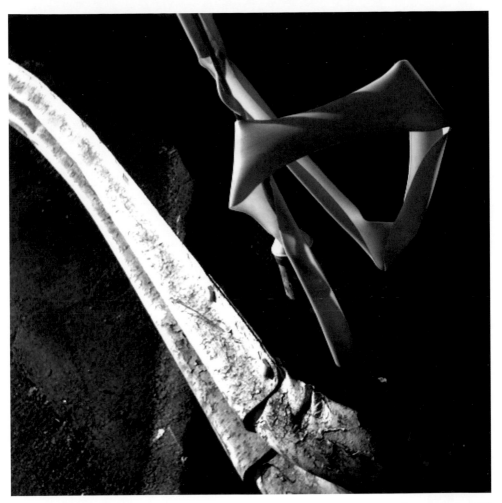

Shoot.

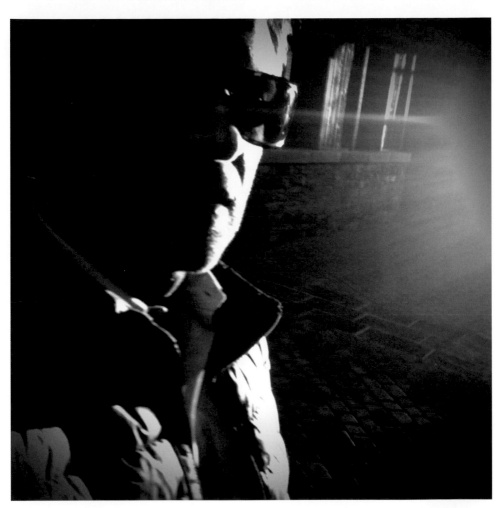

INDEX